IMAGES
of America

SYKESVILLE

IMAGES
of America

SYKESVILLE

Bill Hall

ARCADIA

Published by Arcadia Publishing,
an imprint of Tempus Publishing, Inc.
2 Cumberland Street
Charleston, SC 29401

Printed in Great Britain.

Library of Congress Catalog Card Number: 2001090844

For all general information contact Arcadia Publishing at:
Telephone 843-853-2070
Fax 843-853-0044
E-Mail sales@arcadiapublishing.com

For customer service and orders:
Toll-Free 1-888-313-2665

Visit us on the internet at http://www.arcadiapublishing.com

DEDICATION

To my wife, Carol, whose patience and understanding helped to make this book a pleasure to accomplish.

CONTENTS

ACKNOWLEDGMENTS

Whenever a book is completed, the author must sit back and take note of everyone who has helped in the endeavor. For *Images of America: Sykesville*, I shall try to give an accounting of all those who assisted. It is with a grateful heart that I thank each and every one of them. Above all, I thank my God for having given me this opportunity to preserve history in some small way.

Books and articles used as references for text and captions include the following:
Marck, John T. *Maryland, The Seventh State: A History*. 4th ed. BookMarck, 1998.
National Register of Historic Places, OMB Approval No. 1024-0018.
Articles from the *Sykesville Herald* newspaper.
Warner, Nancy, Ralph Levering, and Margaret Woltz. *Carroll County, Maryland: A History, 1837–1976*. Carroll County Bicentennial Committee and Haddon Craftsman, Inc., 1976.

The organizations that assisted in the compilation of this book include the Town of Sykesville, Maryland (especially their ever-helpful staff); Historical Society of Carroll County, Maryland; Sykesville Gate House Museum of History; Sykesville Historic Commission Archives; Maryland Historical Society; Americana Souvenirs & Gifts, 302 York Street, Gettysburg, PA 17325; Madison Bay Company; www.Carr.Lib.MD.US/Sykes/History.html; and Springfield Hospital Center.

Finally, thanks go to the many people who supplied photographs and anecdotes for this book, including Marian (Dolly) Hughes, Helen Gaither, Gwendolyn Blizzard Seemer, Michael R. Murphy, Maudie Hood Dusome, Jim Wilder, Ross Brooks, Francis Seymour, Thelma Wimmer, Carletta Allen, Annie Werner, Dorothy Schaefer, Cheryl Morgan, Paula Langmead, Barbara Miles, Brenda Werner, Bonnie Smith, the Jones sisters, Nancy Barnes, Calvin Day, Nelson Miles, Katuria Springer, and George Horvath. I would like to give a grateful thanks to Christine Riley of Arcadia Publishing for giving me this opportunity and for all her support. I must give a special thanks to Jim Purman, curator of the Sykesville Gate House Museum and his assistant Kari Greenwalt for their undying assistance in helping me get information for this book. My never-ending gratitude must go to Wiley and Claudia Purkey who were my right arm. They scanned the photographs for me with never a complaint. It was their persistence and suggestion that I do this book on our town and I am ever grateful to them for that. Without these people, organizations, and books, this volume could not have been possible.

INTRODUCTION

The little town of Sykesville, Maryland (pop. 4,200) is resplendent with history, both local and international. Size really does not matter when national history and international intrigue invade the borders of your locale, and Sykesville is loaded with both. In fact, one international incident involved the infamous Napoleon Bonaparte himself.

The Patterson family lived on the Springfield plantation. Betsy, the daughter of William Patterson, one of the wealthiest men in America in 1803, fell in love with Jerome, Napoleon Bonaparte's brother, while he was on a diplomatic mission. They married later that year and when Napoleon found out about it, he annulled the marriage. Betsy never re-married while Jerome became King of Westphalia and husband to Catherine of Wurtemburg, Germany.

In 1825, James Sykes, the man for whom the town of Sykesville is named, purchased less then 1,000 acres. It didn't take long for Sykes to realize the tourist trade potential. He built a four-story, stone hotel on the banks of the river along with a new saw and gristmill, and the town soon became a resort for Baltimore families. The hotel plus numerous neighborhood farmhouses were used for the visiting families during the hot city summers.

The Baltimore and Ohio Railroad exploited the area's potential and extended its "Old Main Line" through "Horse Train Stop" (the town was not yet named Sykesville) in 1831. Since then the railroad has played a very important part in the history of this small town.

In 1845, Sykes enlarged the stone mill and made it into the Howard Cotton Factory. This business flourished until the monetary crisis of 1857 caused work to come to a halt. Shortly thereafter, on July 24, 1868, a devastating flood washed away many of the buildings in town including the hotel.

Sykesville also played a role in the Civil War. On October 17, 1859, Lt. Col. Robert E. Lee and Lt. J.E.B. Stuart rolled through the town on a locomotive on their way to a place called Harpers Ferry to arrest the abolitionist John Brown. Early on the morning of June 29, 1863, Stuart ordered Fitzhugh Lee, nephew of Robert E. Lee, to create mayhem in Sykesville on the way to their destination . . . Gettysburg. They burned the bridge over the Patapsco River, controlled the railroad, and cut telegraph lines. Heading north, they burned the bridge over Piney Run on present-day MD Route 32. The group joined Stuart's Cavalry later that day for a clash with the Delaware Cavalry in Westminster.

Iron and copper ore boosted the economy of the town. In 1851, James Tyson built the Elba Furnace just south of the town along the Patapsco River to smelt the ore, which was then taken by rail to Baltimore. Much of this was used for the construction of car wheels.

In 1884, the B&O Railroad station, designed by E. Francis Baldwin, was built on the north side of the river. This became town property in 1988. In the 1890s, architect J.H. Fowble came to Sykesville, and he was responsible for most of the design and building of Main Street. Some of his credits include the Wade H.D. Warfield Building, the Arcade, two brick bank buildings, and the Kate McDonald home, which is now used as the Sykesville Town House.

On January 15, 1896, Maryland purchased 759 acres from ex-Governor Frank Brown for $100,000. The purchase was for the building of the Second Hospital for the Insane in Maryland, now called Springfield State Hospital. For years the hospital employed many residents from the town and surrounding areas.

In 1904, Sykesville became an incorporated town in Carroll County with Edwin M. Mellor Sr. as its first mayor. Presently, the government consists of a mayor and six council members. Sykesville is one of the few towns that support their own police department.

In 1937, another disaster struck the little town. A fire consumed most of the lower Main Street business district, propelling the town deeper into the Great Depression. During World War II, Sykesville was affected by a state order by Gov. Herbert O'Connor to prohibit Japanese Americans from holding state positions. The State's Central Laundry Correctional Camp, located next to Springfield State Hospital, was forced to fire all its Japanese-American workers.

The 1960s and 1970s almost spelled doom for the town. A bypass was built around Sykesville re-routing traffic away from Main Street and onto MD Route 32. Businesses began to decline and fold. However, in the late 1980s and 1990s a resurgence of prosperity began as the storefronts on Main Street filled to near capacity. A renewing of the spirit of the town soared through festivals, the acquisition of old buildings to be renovated, and community involvement and activities. Currently, a Historic District Commission assures that the past will stay alive.

Today, Sykesville stands as a beacon to those who want to preserve the past, and it is to those people who have ensured that the past will be there for the future that this book is dedicated.

One
MAIN STREET

In America, the center of every small town has been its Main Street, and Sykesville is no exception. This was the assembling place of citizens and the place where decisions were made that would affect all residents. Businesses flourished and fell here, but, most of all, this was where history was made. Main Street has been there from day one. In Sykesville, notables such as Betsy Patterson, Susanna Warfield, Frank Brown, Happy Keeny, Millard Cooper, J.E.B. Stuart, and others have graced the ground that plows through the center of town.

During the 1970s and 1980s, Sykesville experienced the fatal pangs of death as the State of Maryland built a bypass on Route 32 on the east side of town. All the traffic that had once flowed through the town came to a screeching halt. Businesses dried up. Many of the shops folded and left town; many storefronts became vacant. Soon, it seemed, no one knew or even cared to know where Main Street was. It seemed Sykesville was doomed. A resurgence in vitality in the late 1980s and 1990s shot new life into the veins of Main Street. Civic and government involvement brought about fresh changes and ideas, new programs and master plans to provide the boost that was needed. At last, Sykesville had become known as the town that refused to die. Today, storefronts are full, business leaders are renovating and renewing their businesses, and new life has brought economic life to this little town along the Patapsco River.

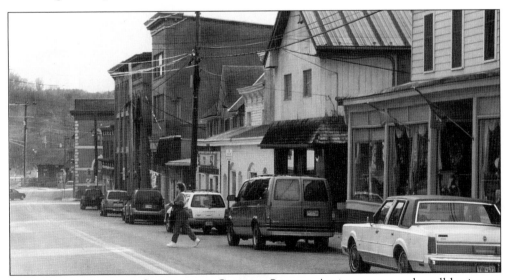

MAIN STREET LOOKING SOUTH FROM CHURCH STREET. Antique stores and small businesses have boomed in recent years. The local thoroughfare looks much like it did when the town was incorporated in 1904—minus, of course, the modern transportation.

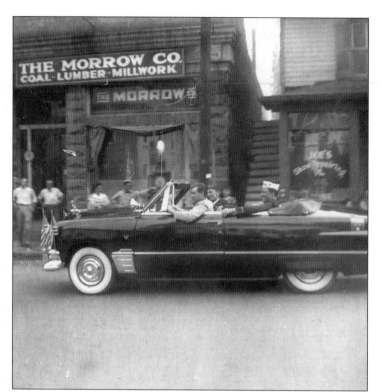

MEMORIAL DAY PARADE. Parades such as this one, pictured *c.* 1950, traveled down Main Street and were much more common in the past than they are today. The parades brought many people to downtown Sykesville. (Courtesy of Dolly Hughes.)

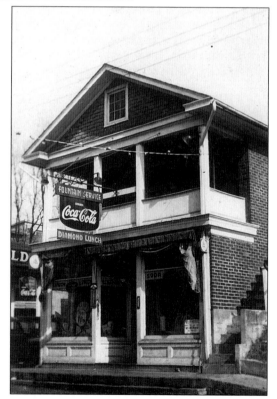

DIAMOND LUNCH ROOM. This lunch room was owned by William and Louise Brandenburg and was popular in the 1950s. It now houses "Hair'N Place" beauty salon. (Courtesy of Dolly Hughes.)

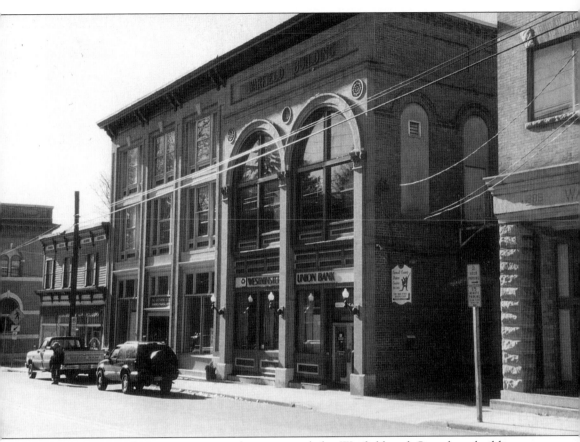

RENOVATIONS. Recent renovations have restored the Warfield and Greenberg buildings to their former glory. These buildings, including Consolidated Stationers on the left, house several businesses. The alleyway on the right leads to one of the town's downtown parking lots. (Photo by the Author.)

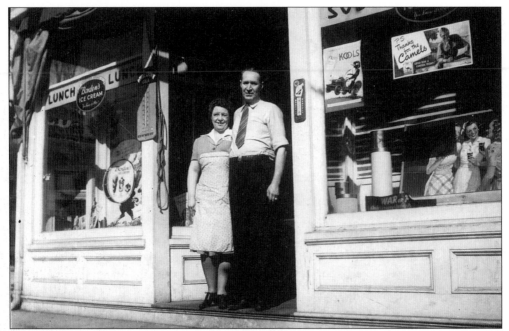

WILLIAM AND LOUISE BRANDENBURG. The Brandenburgs stand in front of the Diamond Lunch Room. William served in the U.S. Navy and eventually became the mayor of Sykesville. (Courtesy of Dolly Hughes).

HAIR'N PLACE. The beauty salon, formerly Diamond Lunch Room, is pictured here today. Note how the second-floor porch has been closed in. To the right is the former Sykesville Fire Department station. The department has since moved four miles away and serves the Sykesville-Freedom District from a much more modern station. (Photo by the Author.)

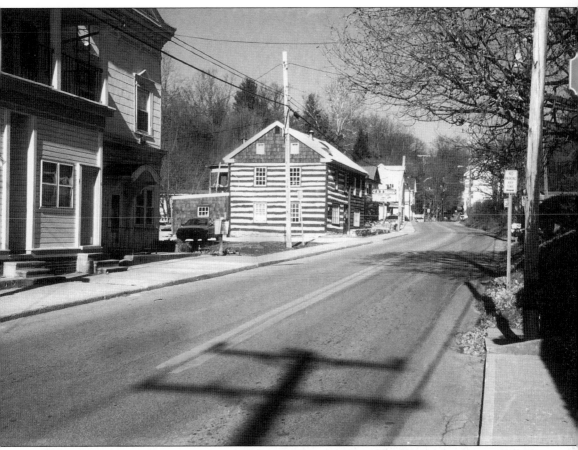

MAIN STREET LOOKING NORTH FROM CHURCH STREET. This view shows a mostly residential section of Main Street that leads north to Springfield Avenue, an extension of Main Street, and Spout Hill Road, leading to the newer parts of town. The building on the left houses apartments while the log cabin is home to Jazzbo's Dog Grooming. (Photo by the Author.)

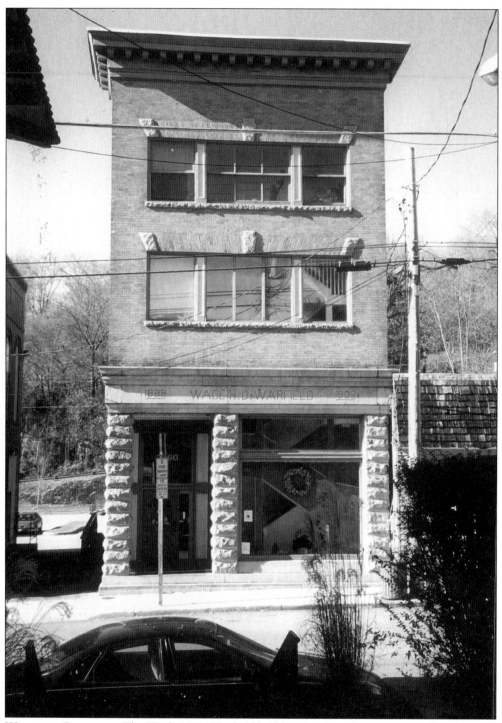

WARFIELD BUILDING. The Wade H.D. Warfield building has been home to many businesses in its more than 100 years of existence. Its namesake was a very influential businessman in Sykesville's early development. The building was built in 1888 and renovated in 1906. (Photo by the Author.)

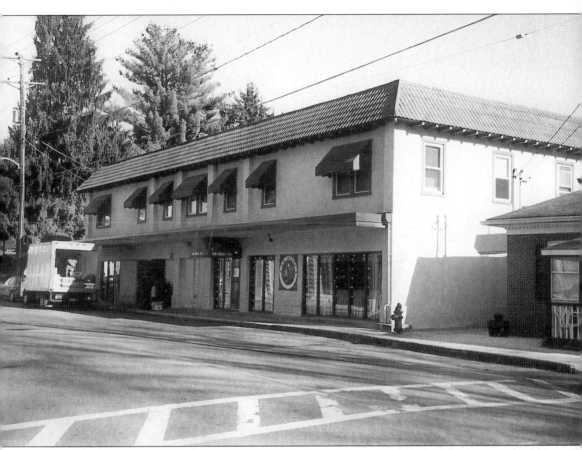

THE HOOD BUILDING. The former Hood building, one of many built by John Edwin Hood, has housed a post office, a theatre, and restaurants in its lifetime. Hood was also an engineer for the Astoria Hotel in New York City. (Photo by the Author.)

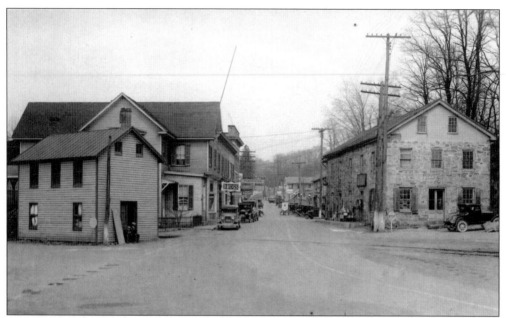

ENTERING TOWN. This 1930s photograph provides a view of the town as one enters from Howard County on the south. This area of Main Street has not changed much over the years. On the right is St. Barnabas Parish House. A bridge over the Patapsco River greets people as they enter town. (Courtesy of Jim Wilder.)

PATAPSCO RIVER. A calm Patapsco River sits on the south edge of town; however, in 1868, it ravaged the former town, which sat on the Howard County side of the river. People watched the devastating flood from atop the hill where St. Joseph's Church now sits. (Photo by the Author.)

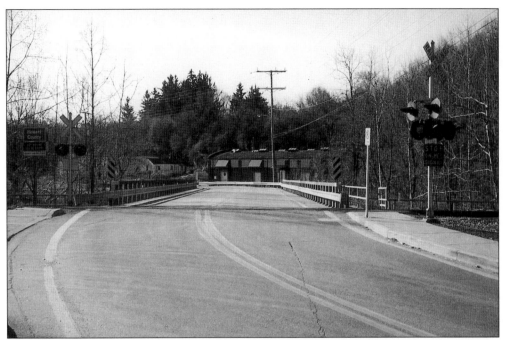

PATAPSCO RIVER BRIDGE. This photograph shows Patapsco River Bridge heading south on Main Street out of town. In the distance is the old Apple Cider Mill, now a vacant shell. Trains still cross the tracks in the foreground every day. (Photo by the Author.)

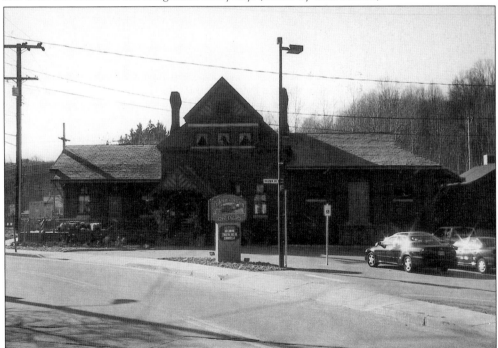

B&O STATION. In 1884, E. Francis Baldwin, an architect, designed the new Victorian Baltimore and Ohio Railroad Station. In its heyday it greeted and sent off thousands of passengers. The station received its last passengers in 1949. (Photo by the Author.)

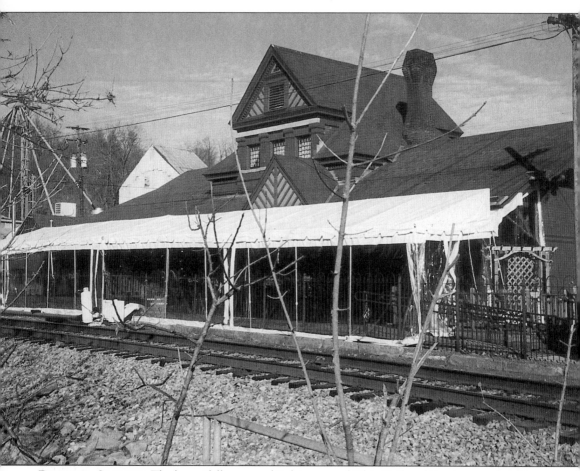

RESTORED STATION. The beautifully restored Baltimore and Ohio Railroad Station now houses a first-class restaurant. In the 1980s, a task force created by the town government saved the station from deterioration. Citizens, businesses, and government worked together to get grants and donations to save the structure. Customers today can still get the feel for the railroad as they eat their food and watch the freight trains roll by. (Photo by the Author.)

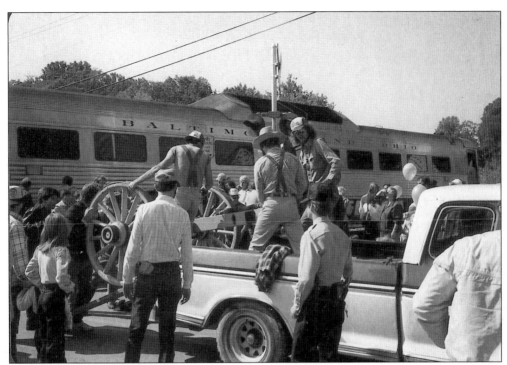

FALL FESTIVAL. Special events such as the Sykesville Fall Festival bring thousands of people to the town and to Main Street for a day of fun and activity. In 1984, attendees were provided train excursion rides to neighboring Mt. Airy, and the train shuttled patrons in both towns to each other's festivals. (Courtesy of the Town of Sykesville.)

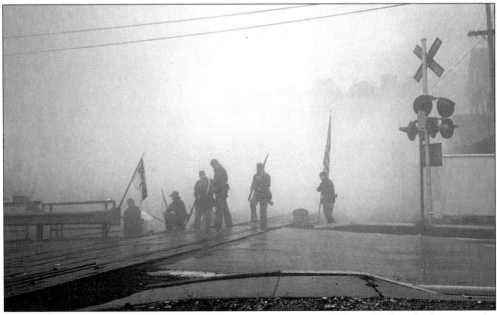

REENACTMENT. A civil war reenactment in the 1986 festival brought hundreds to see the Rebels storm the bridge to Sykesville. They were eventually repelled by Union troops. (Courtesy of the Town of Sykesville.)

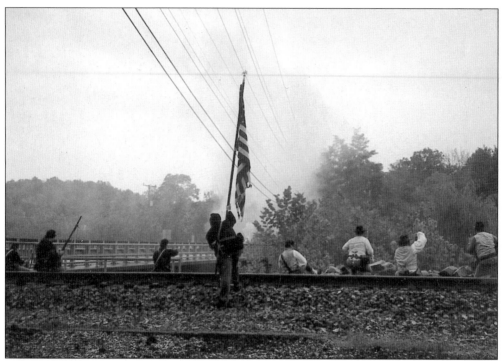

UNION WINS. In the 1986 festival, Union reenactors celebrated as the rebels fled south into Howard County across the Main Street bridge. (Courtesy of the Town of Sykesville.)

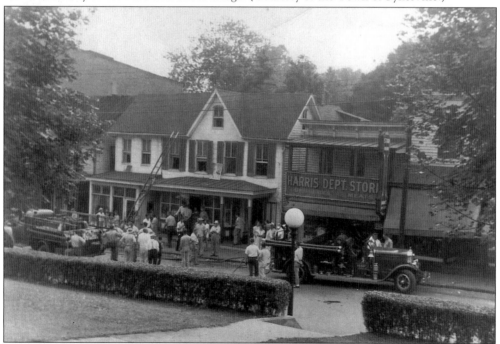

HARRIS DEPARTMENT STORE. Things weren't always calm on Main Street. Here, Harris Department store experiences a close call as fire erupts in a building next door in the late 1950s. (Courtesy of Helen Gaither.)

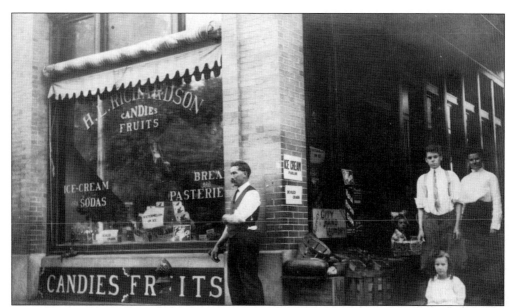

H.L. RICHARDSON. Five people pose in front of H.L. Richardson's candy and fruit store in the first floor storefront of the Arcade Building. Note the variety of products that are available—from deviled crabs to Almond Smash drink—for 5¢. (Courtesy of the Sykesville Gate House Museum.)

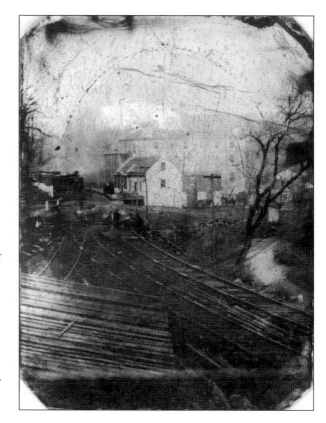

GRIMES HOTEL. This old tintype, thought to be the earliest photo of Sykesville, shows the Grimes Hotel on the right. The hotel and the land it sat on were washed away in one of the worst floods in Maryland history in 1868. Note the workers on the right track. Zimmerman's store in the foreground also served as a station. (Courtesy of the Sykesville Gate House Museum.)

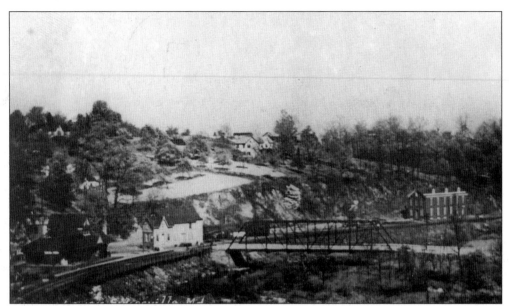

LOWER SYKESVILLE. This view from Howard County shows the old bridge that was washed away by Hurricane Agnes in 1972. On the left is the B&O Station. (Courtesy of the Sykesville Gate House Museum.)

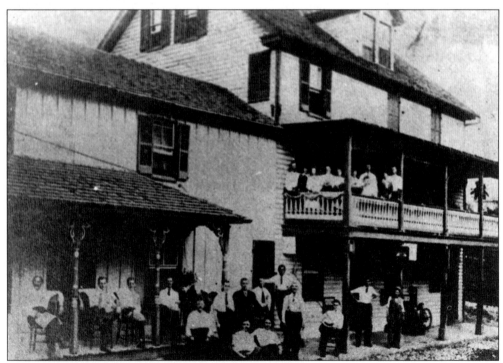

SYKESVILLE HOTEL. This turn-of-the-century photograph shows the hotel on the north end of Main Street. Many travelers stayed here to escape the heat of the big cities. Today the balcony and front porch have been removed. (Courtesy of the Sykesville Gate House Museum.)

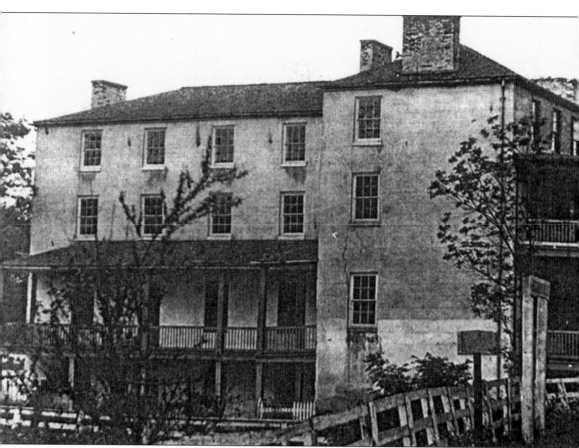

GRIMES HOTEL. This view of the Grimes Hotel shows the massive size of the building. The structure's many porches provided much relief from the hot summer sun. But even as colossal as it was, the building succumbed to nature's fury and was washed away in a flood. (Courtesy of the Sykesville Gate House Museum.)

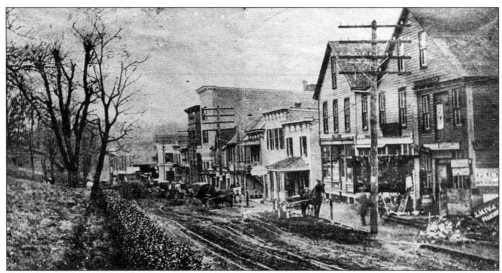

MAIN STREET. In this 1880s or 1890s view, looking south from Church Street, Main Street is covered in mud. Note the numerous ruts in the street caused by the many horses and carriages. (Courtesy of the Sykesville Gate House Museum.)

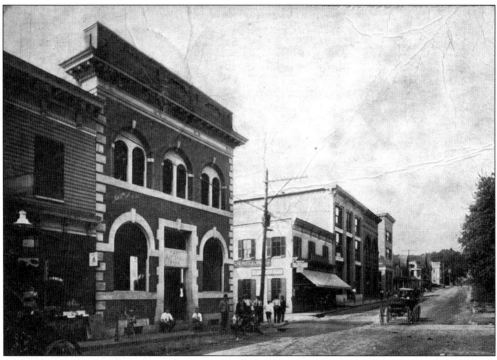

MAIN STREET AND OKLAHOMA ROAD. Gentlemen hang out on a street corner talking about anything from politics to business in this 1920s or 1930s photograph. (Courtesy of the Sykesville Gate House Museum.)

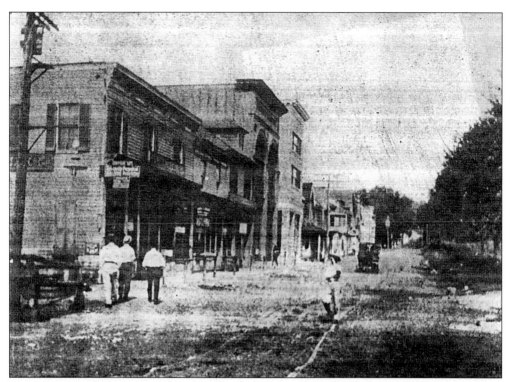

MAIN STREET NORTH. This photograph, taken and published in 1906 by W.W. Ritter, shows a motor vehicle rolling north on Main Street to its destination. Note the tire tracks in the bottom of the photo. (Courtesy of the Historical Society of Carroll County.)

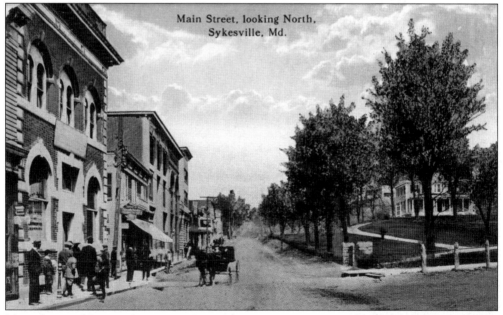

Main Street, looking North,
Sykesville, Md.

MAIN STREET NORTH. A carriage waits to deposit its occupants at the bank building on the left while citizen's stroll north. Note the many hitching posts along Main Street sidewalks. (Courtesy of the Sykesville Gate House Museum.)

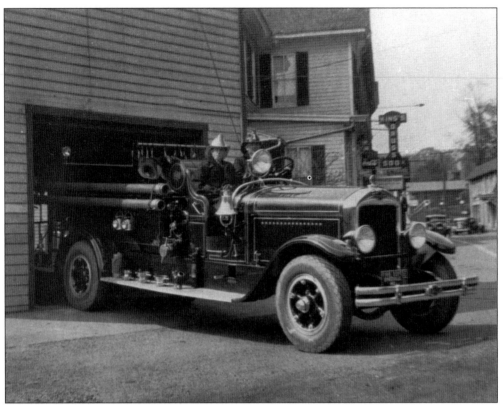

FIRE TRUCK. The Sykesville Fire Department, which was created in 1933, takes pride in presenting their new pumper truck in this photograph. The pumper sits ready to roll with its crew. (Courtesy of the Sykesville Gate House Museum.)

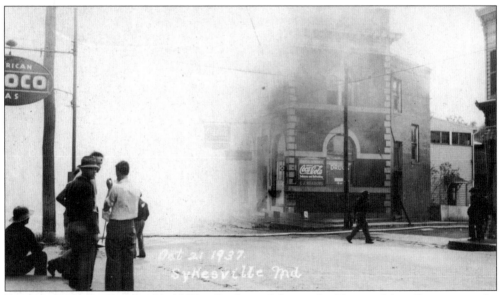

FIRE OF 1937. On October 21, 1937, a fire burned down a building on Main Street as smoke curled over the community. (Courtesy of Jim Wilder.)

Two
PLACES OF WORSHIP

Built in 1836, Springfield Presbyterian Church is the oldest church in Sykesville and was built on land donated by George Patterson. In 1857, the Springfield Institute School was created and served the community until 1900. Over 34 ministers have served the congregation since 1838. In 1986, the church was placed on the National Register of Historic Places.

Another early church was St. Barnabas Episcopal, which grew from Old Trinity in what is now Eldersburg. In 1844, Susanna Warfield petitioned for a new parish because she thought Old Trinity was too far away. On December 11, 1851, the chapel was consecrated. Today several granite slabs from the original B&O Railroad bed can be seen incorporated in the outside walls.

St. Joseph's Catholic Church held its first service in 1868. Its building was completed in 1873, and its first pastor was the Right Reverend Msgr. Barnard J. McManus. Because of the swelling congregation and youth classes, the Church decided to build another facility on Liberty Road. His Eminence Lawrence Cardinal Sheehan led the dedication ceremonies on June 20, 1965.

St. Luke's United Methodist Church was dedicated on November 8, 1898. The church was sold to Benjamin F. Meyers for $5, and it was to be kept as a place for divine worship. Throughout the years that followed, St. Luke's has served as a center for African-American families in the Sykesville area.

ST. PAUL'S CHURCH. St. Paul's United Methodist Church began in Howard County on the south side of the Patapsco River and was built by Rev. Charles Baldwin in 1878. But when most businesses moved to the Carroll County side because of the 1868 flood, the church relocated to its present location on Main Street in 1889. In 1995, the church underwent major renovations. In this turn-of-the-century photo, an iron rail fence with pillars is visible across the front. (Courtesy of the Sykesville Gate House Museum.)

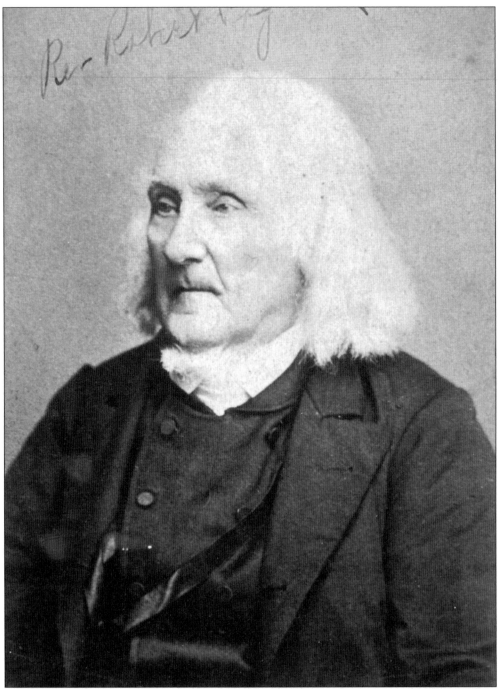

REV. ROBERT PIGGOT. Reverend Piggot moved to Sykesville just in time for the great flood of 1968. Tragedy seemed to follow him as his rectory burned, consuming all of his notes, sermons, and literary works of 53 years. He was pastor of both Old Trinity in Eldersburg and St. Barnabas in Sykesville. Undaunted by ill health and hardship, he was quoted as saying, "I was completely burnt out, left standing in my shoes, in my right place, the pulpit." (Courtesy of the Sykesville Gate House Museum.)

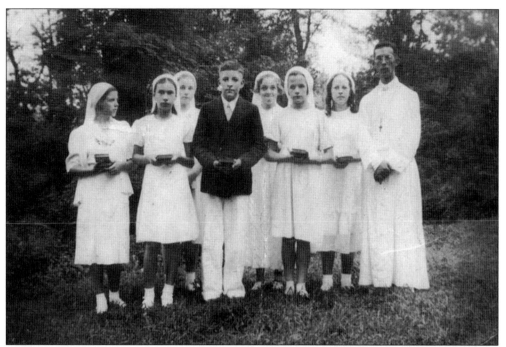

CONFIRMATION CLASS. An unidentified confirmation class of 1936 from Old Trinity Episcopal Church is seen above. (Courtesy of the Sykesville Gate House Museum.)

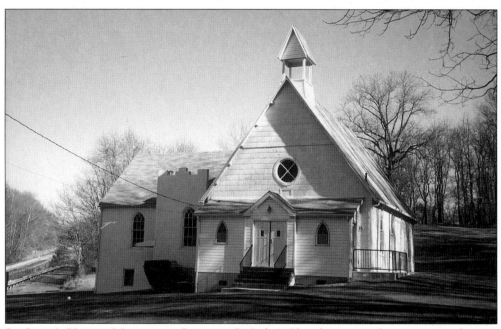

ST. LUKE'S UNITED METHODIST CHURCH. St. Luke's Church is not in the town proper but just south on the Howard County side of the Patapsco River. The church has grown over the years from the original single chapel on the right. It is a spectacular view in the evenings to cars driving north on Route 32 as its beautiful stained-glass windows light up the building. (Photo by the Author.)

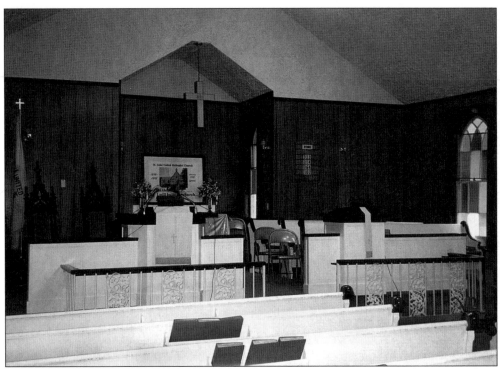

St. Luke's Altar. The church's altar is seen here in the original building. Though small in numbers, the congregation members of this church are mighty in spirit. (Photo by the Author.)

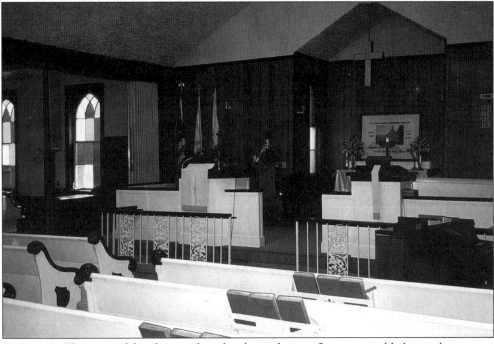

St Luke's. This view of the altar reaches also shows the overflow room, added on in later years. The stained glass maintains the motif from the original structure. (Photo by the Author.)

OVERFLOW ROOM. This welcome addition provided relief for the overcrowded congregation. (Photo by the Author.)

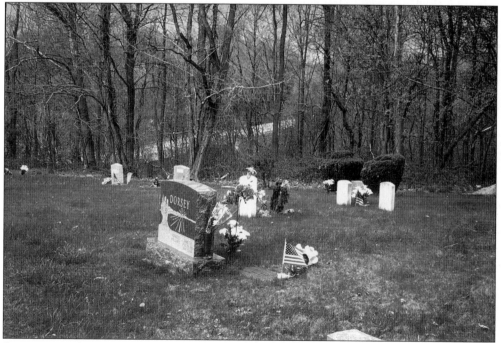

CEMETERY. Like so many older churches, St. Luke's has its own cemetery. It rises above the church on the north end and provides an area for many families, such as the Dorsey and Norris families, to lay to rest their loved ones. (Photo by the Author.)

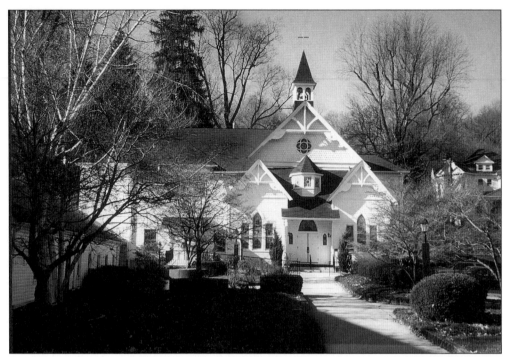

ST. PAUL'S UNITED METHODIST CHURCH. The setting sun bestows a beautiful shadow on St. Paul's Church in this photograph. In 1995, major renovations created more space for the congregation that was bursting at the seams. The long, low building to the left of the church is the Sunday school building and directly on the left of the main church building is the fellowship hall. (Photo by the Author.)

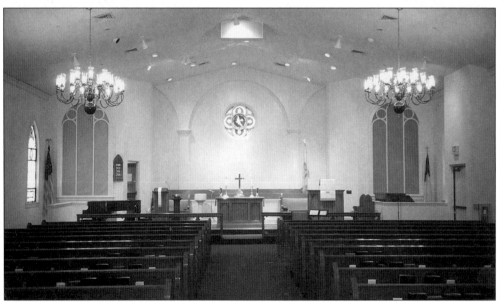

INTERIOR OF ST. PAUL'S. The newly renovated interior combines a warmth of light and modernism with a touch of the old church still visible. In the rear of the church is the "baby room" where parents may take crying infants during services. (Photo by the Author.)

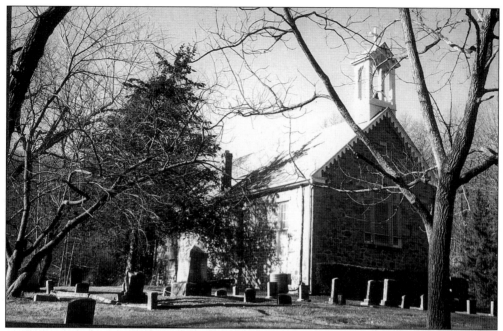

ST. BARNABAS EPISCOPAL CHURCH. This southeast view of St. Barnabas clearly shows the bell tower and the cemetery behind the church with approximately 25 graves. An off-shoot of Old Trinity Church, St. Barnabas has continued to flourish as one of the prominent churches in the area. Its most notable member was Susanna Warfield. (Photo by the Author.)

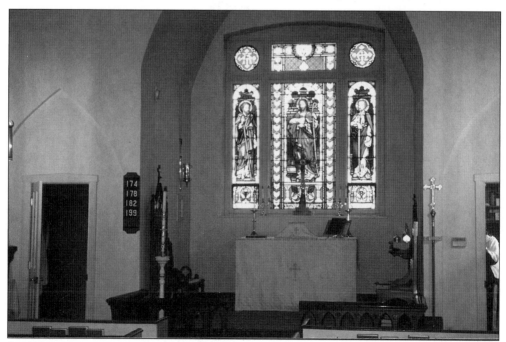

ST. BARNABAS ALTAR. Though small in size, St. Barnabas provides spiritual nourishment for many. Here are the beautiful "Good Shepherd" stained-glass windows that have inspired many. (Photo by the Author.)

ORGAN LOFT. The choir and organ are located in the loft area above the rear of the congregation. An interesting note is that slaves had to sit in this area when they came to church years ago. (Photo by the Author.)

ST. BARNABAS PARISH HOUSE. The parish house was built in 1865 by Dr. Orrelana Owings as a store for his son-in-law; it was one of the few buildings to survive the flood of 1868. The structure served as a store until 1939 when a local volunteer fire department bought it. When the fire company moved up the street in 1949, St. Barnabas purchased the building for its parish house. (Photo by the Author.)

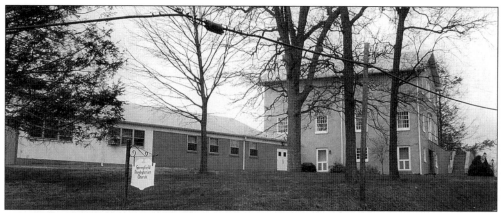

EXTERIOR SPRINGFIELD PRESBYTERIAN. This church is a simple, two-story stucco and stone building with granite steps leading up to the sanctuary. In 1962, the educational wing on the left was added to provide schooling for kindergartners. (Photo by the Author.)

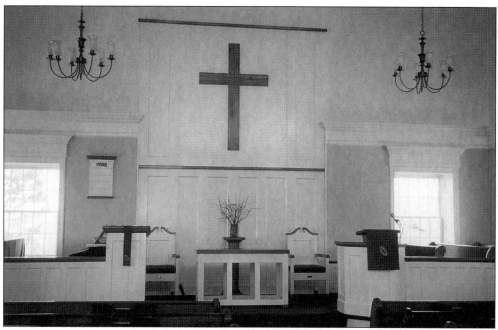

ALTAR. Springfield Presbyterian Church's altar is plain and simple but still lends beauty to this scene just as those in other churches in town. Since 1838, over 34 ministers from as far away as Scotland, New Zealand, and China have served from this pulpit. (Photo by the Author.)

SPRINGFIELD PRESBYTERIAN CHURCH. Its plain, stucco exterior by no means tells the tale of this great church. Entry to the church is on both sides of the granite steps that have welcomed such notables as Stephen T.C. Brown, the father of Frank Brown, who was to become the only governor of the State of Maryland from Carroll County. (Photo by the Author.)

SPRINGFIELD CEMETERY. The cemetery was enlarged in 1981 when George Patterson gave the church this land. In 1931, the cemetery was divided from the church property and managed by the Springfield Cemetery Company. Prominent people buried here include George Patterson, Stephen T.C. Brown, and members of the Beasman, Flohr, Brown, DeVries, Carter, and Ridgely families. (Photo by the Author.)

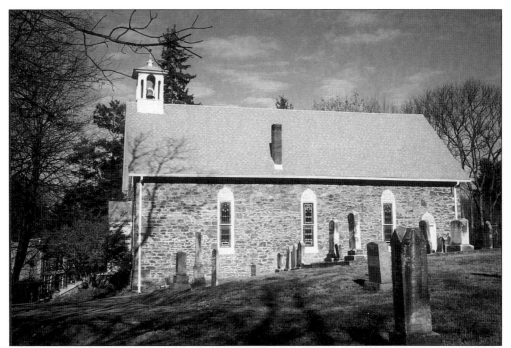

ST. JOSEPH'S CATHOLIC CHURCH. This elegant, stone church was built on the hilltop in 1868 just off Main Street looking down at the flowing Patapsco River. Even without the roof completed, parishioners made a makeshift altar out of soap and starch boxes. The rear wall collapsed even before the church was finished being built, but construction was completed in 1873. (Photo by the Author.)

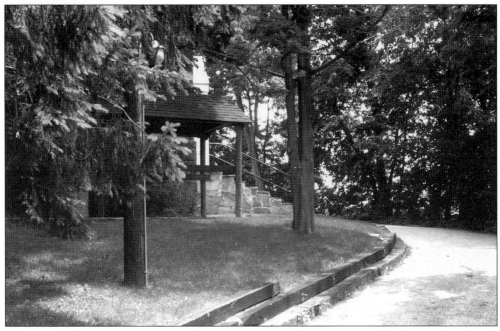

WALKWAY. This serene, covered walkway encompasses the property and leads into the church. Its leafy roof provides shelter from the sun, rain, and even birds. (Courtesy of Francis Seymour.)

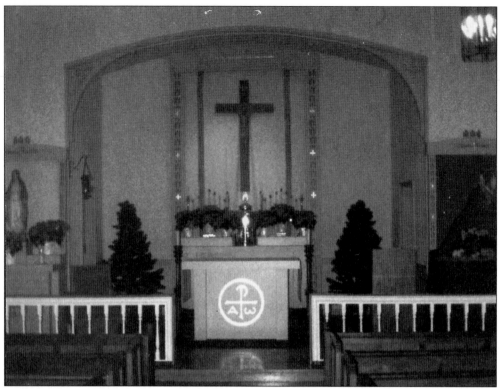

ALTAR OF ST. JOSEPH'S. The beautiful altar arrangement on Christmas Day, 1987, shows St. Joseph's Church at its finest. Note the Christmas decorations adorning the altar. (Courtesy of Francis Seymour.)

NEW CHURCH. Due to a near-capacity attendance, St. Joseph's staff searched for a new facility. In 1965, the found it on Liberty Road, approximately four miles north of the original church. The first Mass was held on May 23, 1965. (Courtesy of Francis Seymour.)

Three

THE RAILROAD

The railroad has always been important to the Town of Sykesville. On December 1, 1831, the B&O Railroad extended its "Old Main Line" past Ellicott Mills through Sykesville to Point of Rocks, Maryland. At one point a strike by workers for unpaid wages almost brought the railroad construction to a halt. Of course, Sykesville was not known as Sykesville then but was called "Horse Train Stop."

Many Baltimoreans came by railroad to Sykesville to visit the summer homes or cottages of residents. Over the years mining became big business in the area and ores were shipped by rail to the city 25 miles away. During the Civil War, the tracks were torn up and telegraph poles torn down as Confederate troops headed north to Gettysburg. Notables such as Robert E. Lee and J.E.B. Stuart rode through the little hamlet. In 1883, E. Francis Baldwin designed and built a Queen Anne–style rail station on the north side of the river. The station saw passenger service end in 1949.

But there was another train in Sykesville. The "Dinky Train" and a three-and-a-half mile track connected Springfield State Hospital to the B&O Railroad by a spur track from 1908 to 1972. By doing this, the tracks went through (and some still do) many back yards of Sykesville homes. In 1999 and 2000, town officials negotiated the sale of a 1949, 12-gauge F-3 Diesel engine and passenger cars for a miniature children's train. The train may look familiar to train buffs as it was patterned after the Pennsylvania Railroad. The "Little Sykes Railroad's" debuted at the 2000 Sykesville Fall Festival.

SYKESVILLE TRAIN STATION. The Sykesville Train Station is pictured from the second-floor back porch of John and Alberta Harris's home on Mellor Avenue between 1947 and 1952. (Courtesy of Helen Gaither.)

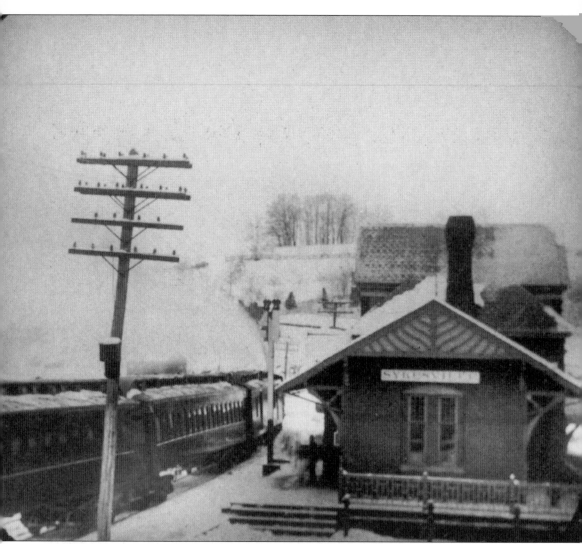

SYKESVILLE STATION. This early, undated photo of the Sykesville Train Station, built between 1883 and 1884, shows passenger cars in all their glory. People by the score came to Sykesville to enjoy cool relief from the hot cities and the beauty of the little village. The "Old Main Line" was extended from Ellicott Mills through Sykesville in 1831. (Courtesy of the Town of Sykesville.)

TRAINS HEADING WEST.
Trains heading west meander through Sykesville. The thick, black smoke from the locomotives was a common sight to residents of the low-lying village. (Courtesy of Helen Gaither.)

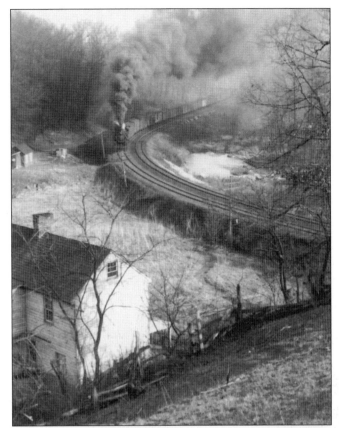

WAITING. Helen (left) and Adele Harris await the start of their journey on a period bench for a train to who-knows-where. They are seated inside the B&O Station on the south end of town. (Courtesy of Helen Gaither.)

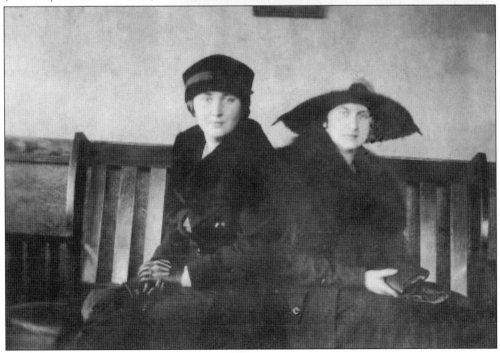

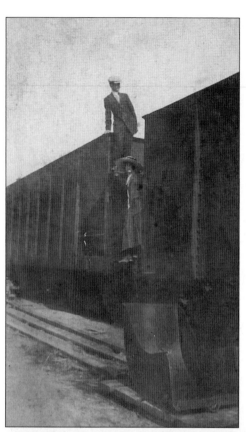

TIME TO PLAY. Trains were not only a source of travel and work. Here, two young people play on hopper cars, c. 1920. (Courtesy of Helen Gaither.)

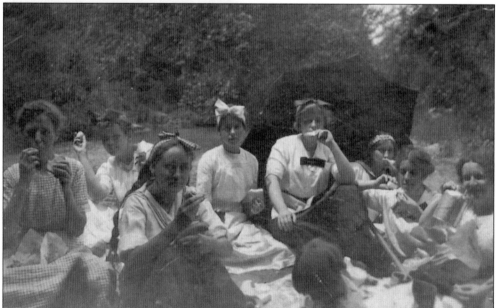

LIFE ALONG THE RAILS. Life along the rails provided other sources of entertainment. Sykesville young ladies, shown here in the early 1900s, share their lunch beside the rails along the Patapsco River. (Courtesy of Helen Gaither.)

SOUTH END TRACKS. The railroad runs along the south end of town and near the top of the tracks is the B&O Station. In 1850, a young girl stopped a crash from happening somewhere along these tracks. An embankment collapsed onto the tracks caused by the rain. She, alone, retrieved a lantern, waved it frantically, and as a result was able to stop the train in time. (Photo by the Author.)

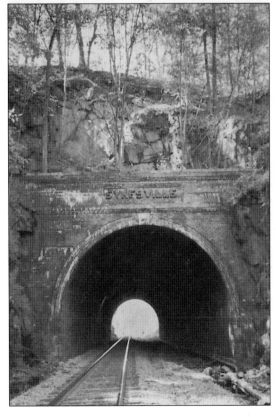

SYKESVILLE TUNNEL. The Sykesville Tunnel stands west of town, allowing trains to enter the incorporated limits. Its Romanesque arch reflects the construction of the day. Tunnels such as this one dot the Mid-Atlantic region. (Photo by the Author.)

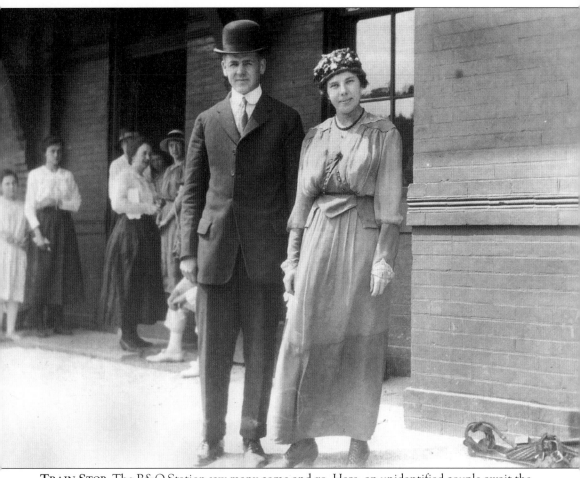

TRAIN STOP. The B&O Station saw many come and go. Here, an unidentified couple await the beginning of their journey. The third person from the left, wearing a white blouse and black skirt, is Adele Harris. (Courtesy of Helen Gaither.)

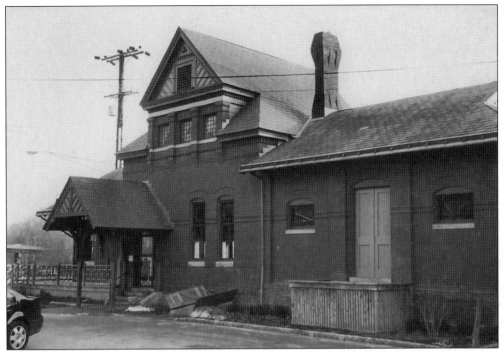

TRAIN STATION. The front of this Victorian-era train station is shown above as it appears today. Before the town saved it, the depot was only used for the storage of parts and equipment for the railroad. Today, it is a testament to historical fortitude. (Photo by the Author.)

VISITORS. The trains brought in all kinds of people. Many stayed in various homes in town. In 1943, Adele and Helen Harris provided a home for the two British sailors on the left—Jimmy Eastman from London and Lewis Reid from Newfoundland. The sailors were on "R & R" while repairs were made to their ship in Norfolk, Virginia. (Courtesy of Helen Gaither.)

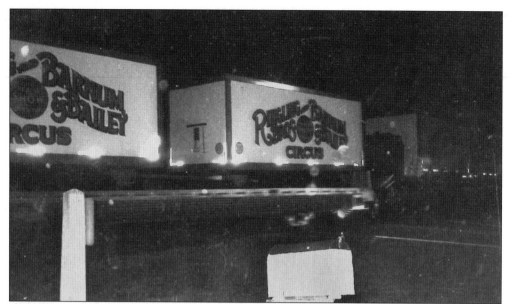

CIRCUS. For years, mostly in the month of March, the Ringling Brothers and Barnum and Bailey Circus Train has rolled through Sykesville, usually in the evenings, on its way to a performance of the "greatest show on earth" in Baltimore, Maryland. (Photo by the Author.)

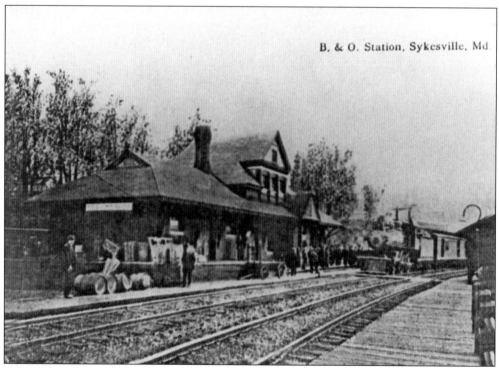

B. & O. Station, Sykesville, Md.

B&O STATION. This picture of the B&O Station was probably taken not long after the station opened in 1883. With the train arriving, workers are busy getting ready to take care of their passengers and cargo. Note the platform on the right, which is not there today. (Courtesy of the Sykesville Gate House Museum.)

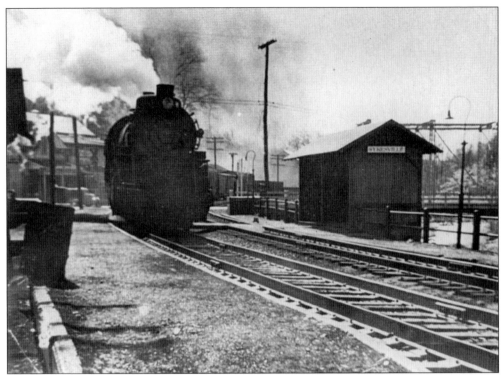

HEAR THAT TRAIN A'COMIN'. This photo, taken between 1920 and 1930, shows an engine rolling into Sykesville Station. The small shelter on the right is no longer there and the bridge on the far right was washed away in 1972. (Courtesy of the Sykesville Gate House Museum.)

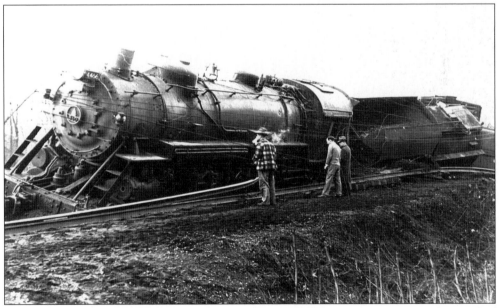

DERAILMENT. In this photo, taken between 1930 and 1940, two workers examine the wreck of the #4466. Note the massive size of the train and the twisted track. On the right, other cars beyond the tender are off the tracks. (Courtesy of the Sykesville Gate House Museum.)

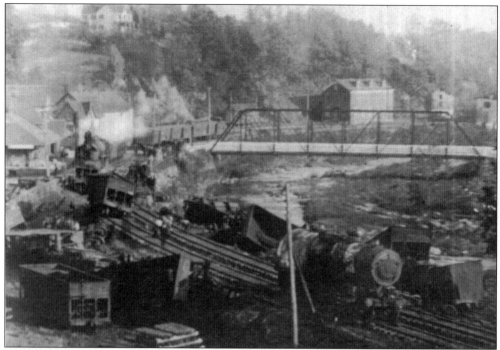

ACCIDENT. Railroad workers begin the arduous task of removing the massive bulk from a train crash probably at the turn of the century. The job was made more difficult due to the cars falling into the river. Most of the buildings seen in this photo still stand today. (Courtesy of the Sykesville Gate House Museum.)

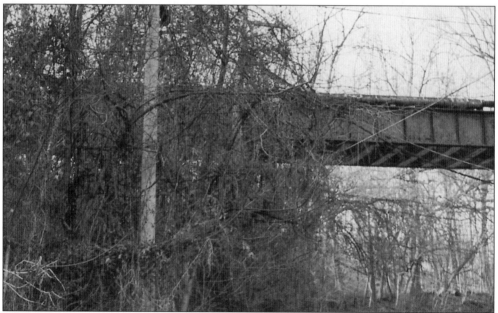

"THE DINKY TRESTLE." From 1908 to 1972, the "Dinky Train" ran supplies and coal to Springfield State Hospital. Today, though run down, the trestle still stands as a monument over Spout Hill Road. (Photo by the Author.)

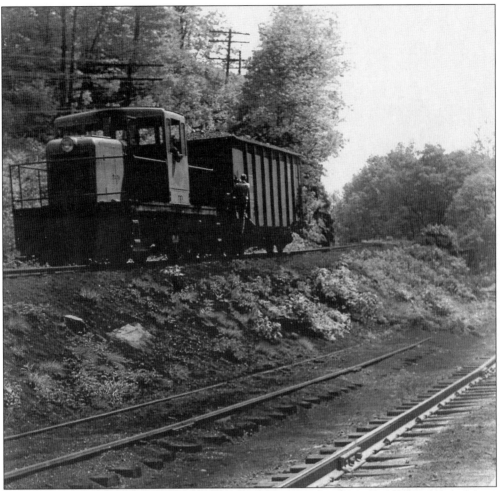

DINKY. An engineer and a worker ride on the Dinky Train to Springfield Hospital to deliver coal to the facility. Note the load of coal protruding from the top of the hopper car. The Dinky halted service in 1972. (Courtesy of Springfield Hospital Center.)

PULLMAN CAR. A recent addition to the town's train theme is this restored 1910 Pullman car, housing a car-long model train display representing many gauges of model trains. The Sykesville and Patapsco Railroad Society completed the work. (Photo by the Author.)

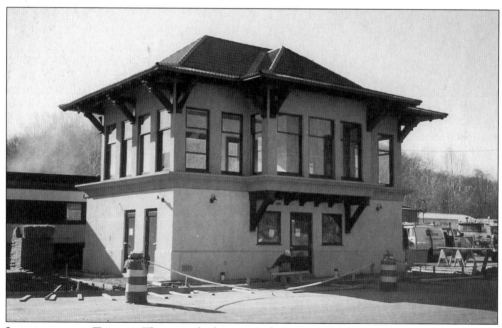

INTERLOCKING TOWER. This interlocking switch tower, shown under construction, was originally housed at the famous Penn Station in Baltimore City. It was rebuilt and opened in 2000 using many of the original parts. It houses a large meeting room on the second floor, while the first floor has public restrooms, storage, and a visitor's center. (Photo by the Author.)

Four
ALL AROUND TOWN

Sykesville has a lot going for it. Sometimes called the "Gateway to Western Maryland," it is nestled between Maryland Route 26 and Interstate 70, just 25 miles northwest of Baltimore. The town itself sits along the north shore of the Patapsco River in Carroll County, Maryland. The county's most famous citizen is, without a doubt, Francis Scott Key, the author of "The Star-Spangled Banner."

Northwest of town is Piney Run Park, a recreational area used by hundreds of people from not only Sykesville but the entire surrounding area. Activities include boating, fishing, nature tours, and tournaments. Northeast of town is the Liberty Reservoir, a gigantic lake system that provides drinking water for the Baltimore metropolitan area. Fishermen and boaters use the area as well. Southwest of Sykesville is the nation's capitol, Washington, D.C. With so many things to see and do in Washington and Baltimore, nearby Sykesville has become an appealing spot in which to reside.

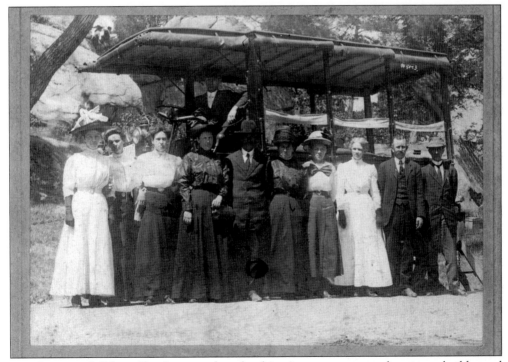

BUS SERVICE. J. Edwin Hood, pictured in the driver's seat, was more than just a builder and engineer. Here, he is shown with the first bus service from Ellicott City to Sykesville. The other individuals pictured are unidentified. (Courtesy of Maudie Dusome.)

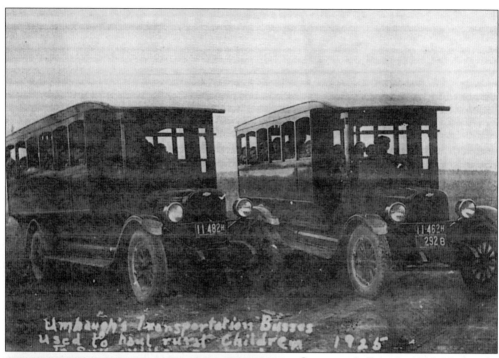

Umbaugh's Transportation Busses
used to haul rural children 1925

CHILDREN'S BUS. In 1925, Umbaugh Bus Company transported children to nearby Sykesville School. These buses were mainly used for children in the rural areas. (Courtesy of the Historical Society of Carroll County.)

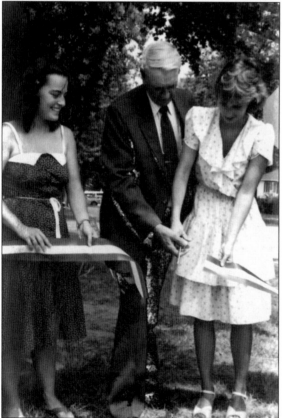

COOPER PARK. Millard Cooper Park, the town's first official park, was dedicated in 1983. Here, Kathy Young, William R. "Mac" McElroy, and Patty Cooper Meyer, cut the ribbon, officially opening the park. (Courtesy of the Sykesville Gate House Museum.)

RICHARD DIXON. State delegate Richard Dixon of Carroll County presided over the opening ceremonies at the opening of Cooper Park in 1983. Dixon later went on to become the first African American to become treasurer of the State of Maryland. (Courtesy of the Sykesville Gate House Museum.)

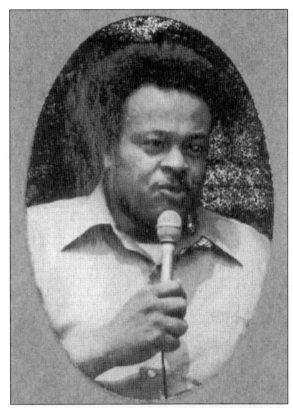

CIRCLE X RANCH. Just south of town in Howard County, Guenther Beer sponsored the Circle X Ranch during the summer from 1950 through the 1960s. Rodeos and bull riding were a delight to children of all ages. Here, Harold Gaither pulls a wagonload of children to their next stop. The farm, formerly the Warfield farm, was the property of John Erickson. (Courtesy of Helen Gaither.)

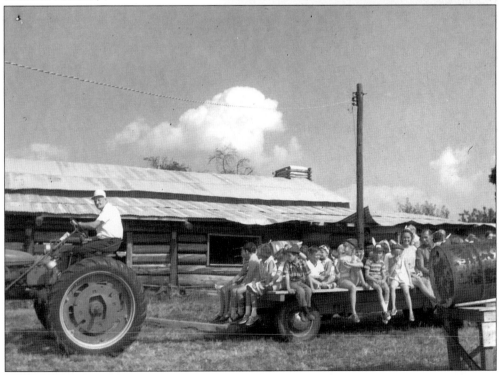

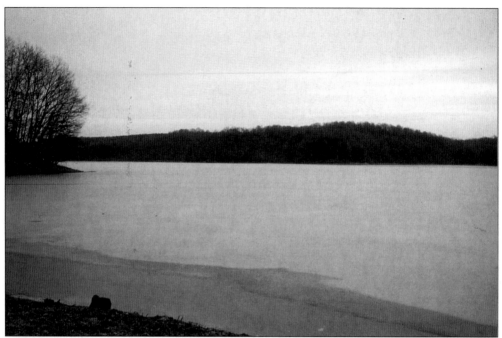

LIBERTY RESERVOIR. Liberty Reservoir, a large lake system, serves as a water supply for the Baltimore region, of which Sykesville and Carroll County are a part. Its majestic scenery has brought thousands to its shores for recreation and fishing. (Photo by the Author.)

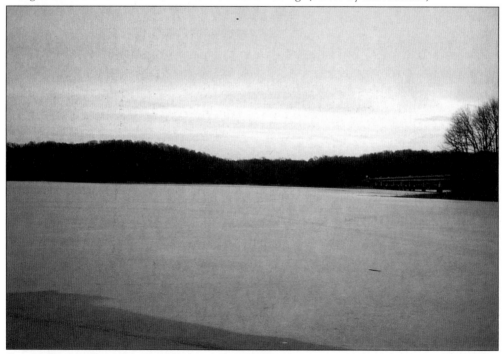

RESERVOIR LOOKING SOUTH. This view shows Liberty Reservoir looking south. To the right is one of the many spans that cross the lake system. This one is Liberty Road (MD Route 26). (Photo by the Author.)

COOPER PARK. Cooper Park is one of the most used parks in Sykesville, and people from as far away as Baltimore have come to use its facilities. Along with its unique nature trail are many park amenities. The new public restrooms and concession stand are to the right. (Photo by the Author.)

COOPER PARK. Pavilions, playgrounds, and trails are available for visitors and make for quite a day of fun. Several festivals are held at the park each year, as well as the ever-popular "Concerts in the Park" series each summer. (Photo by the Author.)

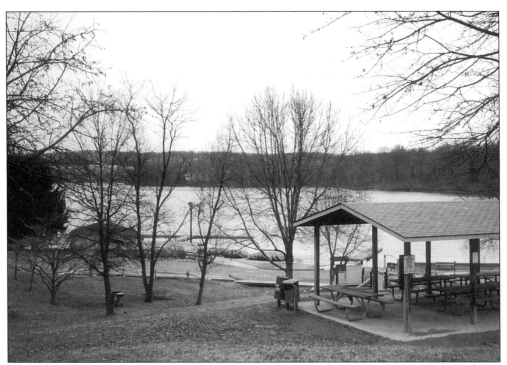

PINEY RUN PARK. Piney Run Park, a county-run park just northwest of town, is a haven for fun-lovers. Wildlife abounds here—along with humans—in a very natural setting. (Photo by the Author.)

PINEY RUN. Piney Run, a man-made lake, offers visitors boating, fishing, nature trails, and a wonderful nature center. Fishing and boating piers, along with a boat ramp, take fishermen and boaters out to the fish. It is a well-utilized facility and very popular in the surrounding area. (Photo by the Author.)

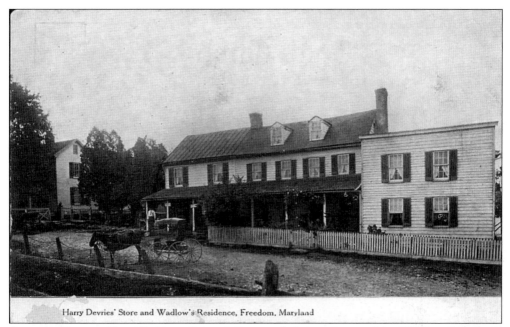

Harry Devries' Store and Wadlow's Residence, Freedom, Maryland

GENERAL STORE. Harry DeVries General Store and the residence of the Wadlow Family are seen in this photograph. These structures, pictured around the turn of the century, no longer exist but sat off what is now Old Liberty Road in Eldersburg, just north of Sykesville. (Courtesy of Dolly Hughes.)

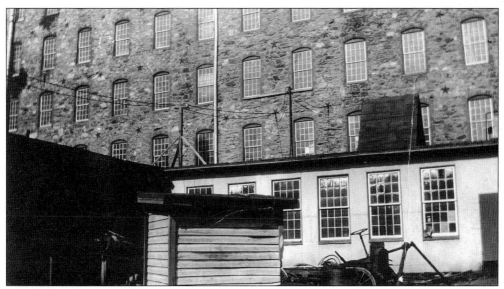

OAKLAND MILLS. This picture, taken on April 27, 1919, shows the Oakland mills, northeast of Sykesville near what is now Liberty Dam and Reservoir. (Courtesy of Dolly Hughes.)

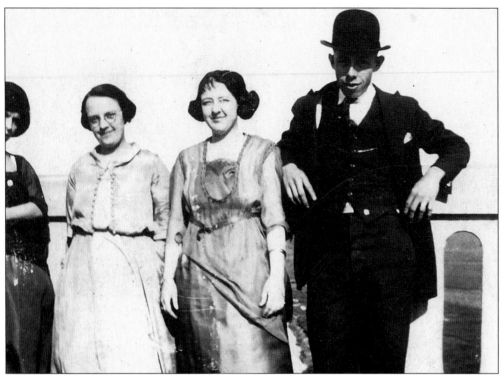

SUNDAY STROLL. Out for a relaxing Sunday stroll in April 1921 on the Springfield property are, from left to right, Frances Young, Ethel Price, Anna Berry, and Harry Parsley. The group stopped for this picture on the Springfield Bridge. (Courtesy of Dolly Hughes.)

CIDER MILL. The old cider mill sits neglected just across the bridge in Howard County. Town officials are working with Howard County officials to try to preserve the mill and return it to its former glory. (Photo by the Author.)

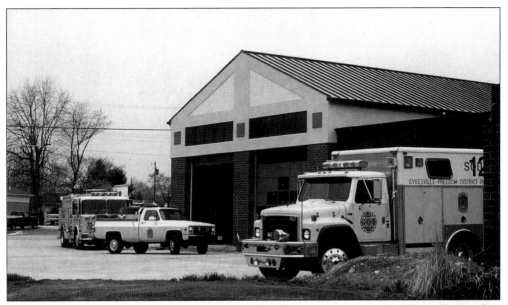

FIRE DEPARTMENT. The Sykesville Volunteer Fire Department, now the Sykesville-Freedom District Volunteer Fire Department, is located two miles north of town on MD Route 32. Here is a pumper, brush unit, and rescue squad waiting for service. The department was undergoing new construction as the time this picture was taken in 2001. (Photo by the Author.)

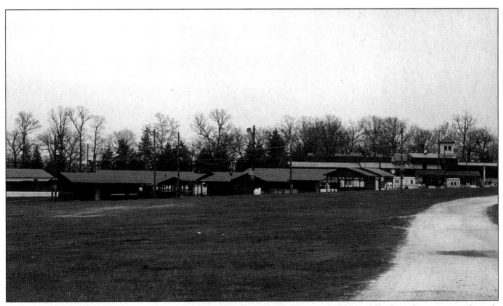

FAIRGROUNDS OF THE FIRE DEPARTMENT. These vacant grounds are filled with a carnival each year in June. Various activities such as fairs, flea markets, and festivals have been held here. (Photo by the Author.)

SOUTH ENTRANCE. Flowers bloom and brighten the day of passersby at the south entrance of Sykesville and Howard County. Two salons were once located on the right but were bought and torn down. (Photo by the Author.)

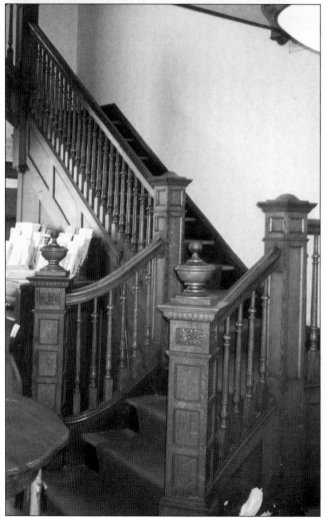

STAIRWAY. You don't have to go too far to see beautiful workmanship from a bygone era. This stairway rises to the second floor of the Town House on Main Street.

Five

Springfield Hospital Center

Springfield, the estate of George Patterson until his death in 1869, has a fascinating history. One of the most admired homes in Maryland, it provided many amenities that were to make it famous: water, wood, iron, and copper. The latter were mined from 1850 to 1861. After being elected governor of Maryland in 1892, Frank Brown, former manager of Springfield and a state delegate, sold the property to the State for $50,000 for the purpose of providing a home for the mentally ill. The 728 acres included the Patterson mansion. In 1896, $100,000 was appropriated for the construction of buildings. On July 6, 1896, five patients were transferred from Spring Grove Hospital to Springfield.

In 1898, the Service Building and several cottages were built. The cottages are still known as the "Men's Group." In 1900, a similar group of cottages was built for women, and in 1901, a practical school of nursing was established. John Hubner, a senator who helped establish the hospital, oversaw the construction of most of the buildings at Springfield. To this date, one of the most prominent buildings bears his name. Between 1924 and 1929, new buildings were established. By 1832, there were 2,410 patients at Springfield.

In the 1990s, the State sold 138 acres of the hospital known as the Warfield Complex to the Town of Sykesville. The Town will develop that area for multiple uses and ensure its historical character.

THE "T" BUILDING. The T Building, constructed in 1939, was to receive all the white mental patients with tuberculosis in the State of Maryland. (Courtesy of Springfield Hospital Center.)

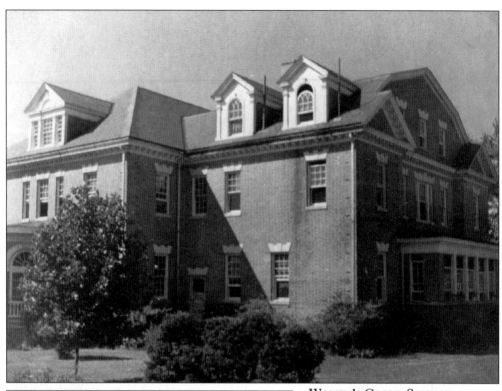

WOMEN'S GROUP SERVICE
BUILDING. Built in 1900, this three-story Colonial house provided heating facilities, coal, and vegetable storage, as well as two dining rooms. It is connected to three other buildings—A, B, and C—by covered walkways. (Courtesy of Springfield Hospital Center.)

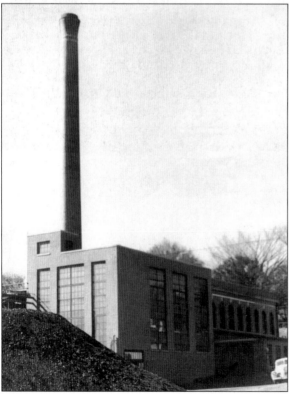

LOCOMOTIVE HOUSE. This 1912 brick structure housed the switching connections for railroad operations at Springfield. (Courtesy of Springfield Hospital Center.)

PATTERSON HOUSE. In 1912, the original house built in the 1790s burned down. The house in this photograph was built in 1913 after the original wood frame house was destroyed. Dr. George H. Rohe chose this house to be the home for the superintendent and to hold administrative offices. (Courtesy of Springfield Hospital Center.)

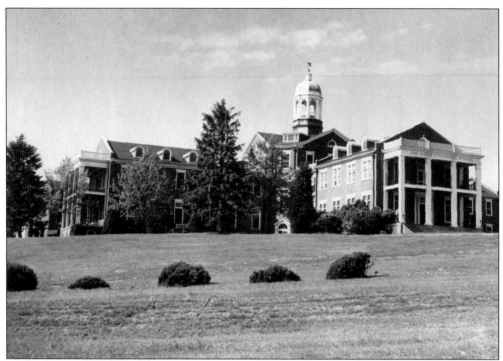

HUBNER PSYCHOPATHIC HOSPITAL BUILDING. This majestic building, constructed in 1915, was used for the reception, diagnosis, and treatment of acute mental diseases patients. The basement contained dressing and hydratic rooms, a pharmacy, and x-rays. The first floor north held administrative offices, a library, and physician's rooms and offices. The second floor was for staff. The third floor contained operating, anesthesia, and recovery rooms, and a lab. (Courtesy of Springfield Hospital Center.)

DAIRY BARN. In 1922, this dairy barn was constructed as another effort to make Springfield Hospital Center a self-sufficient facility. Herds of cattle were maintained for beef and milk. (Courtesy of Springfield Hospital Center.)

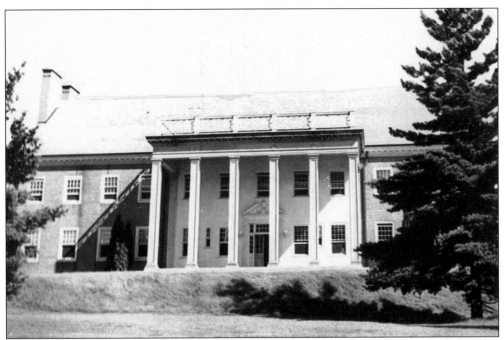

WOMEN'S GROUP 1. This 1929 Georgian Revival structure was an infirmary ward for somatic diseases. Its layout allowed for the isolation of patients with infectious diseases. (Courtesy of Springfield Hospital Center.)

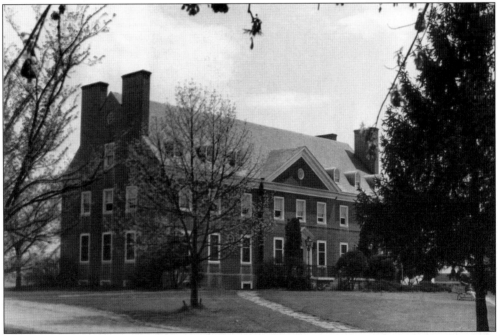

NURSES' HOME. The nurses' home was built the same time as the Men's Group K and the Vocational Group Rehabilitation Building in 1932. Springfield tried to provide accommodations for those interested in these subjects. Today, the Fire and Police Department make it their station. (Courtesy of Springfield Hospital Center.)

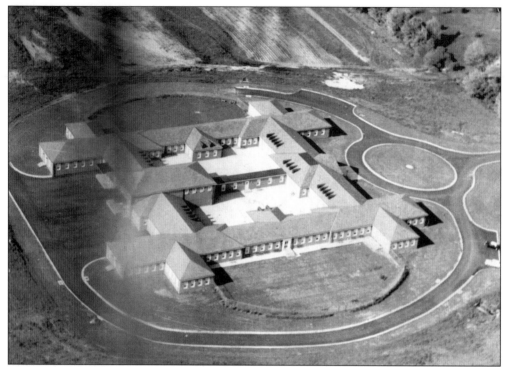

THE LANE BUILDING. Built in 1953, this structure was the newest building on the hospital grounds until 1968 when the new Administration Building was erected. (Courtesy of Springfield Hospital Center.)

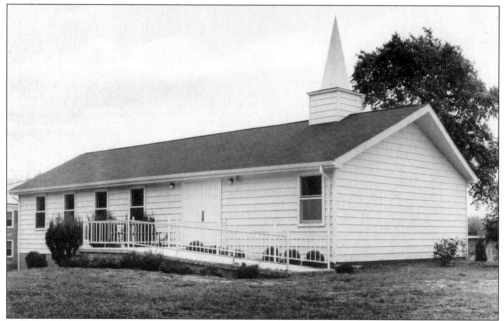

SPRINGFIELD MEMORIAL CHAPEL. This building was dedicated in 1981, and services prior to 1975 were held at temporary sites and in the basement of the T Building. (Courtesy of Springfield Hospital Center.)

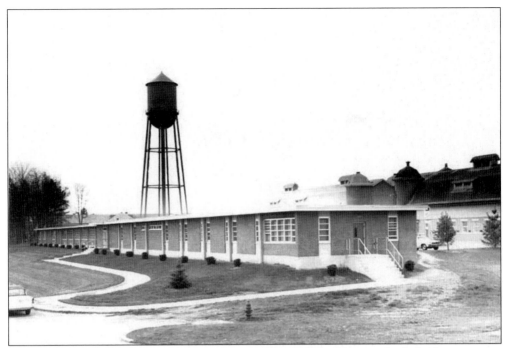

WENDALL MUNCIE CENTER FOR ADOLESCENTS. This 1972 building was built for the treatment of emotionally disturbed adolescents aged 12 to 20 and could house 45 to 50 patients. (Courtesy of Springfield Hospital Center.)

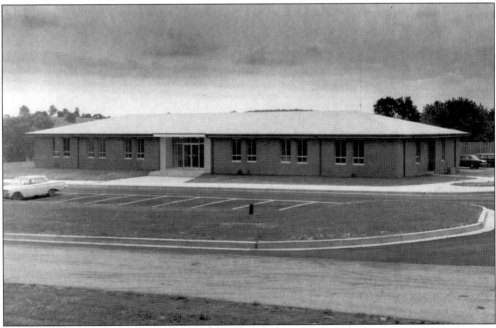

NEW ADMINISTRATION BUILDING. Dedicated on June 20, 1968, this new building housed the superintendent, the assistant superintendent, the clinical and associate clinical directors, accounting, personnel and purchasing, HMIS/contracts, the main switchboard, and the mailroom. (Courtesy of Springfield Hospital Center.)

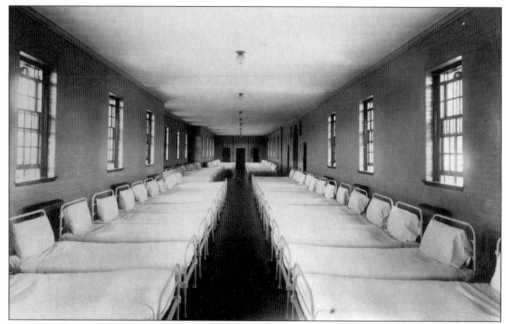

MARTIN GROSS A-WARD PATIENTS DORMITORY. This is a view of a hospital ward with two rows of beds. Today's one- and two-bed hospital rooms have replaced this all-too-familiar scene from the past. (Courtesy of Springfield Hospital Center.)

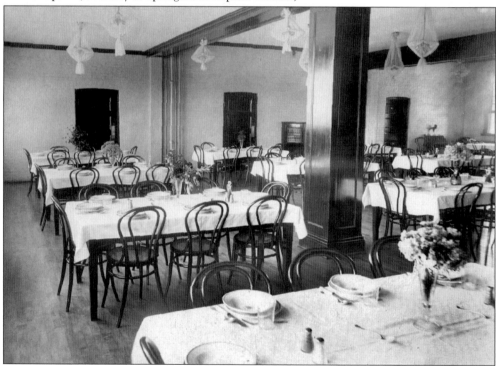

DINING HALL. This photograph displays the elegance of these majestic buildings, not just on the outside but on the inside as well. This interior provided much comfort to those required to use the center's facilities. (Courtesy of Springfield Hospital Center.)

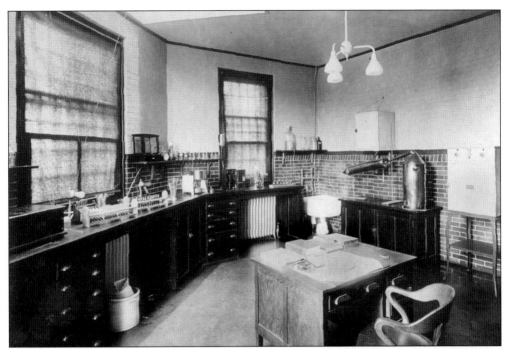

LABORATORY. This was one of the many labs used at Springfield. The lab rooms, some larger and some smaller, were used for research and medical needs. (Courtesy of Springfield Hospital Center.)

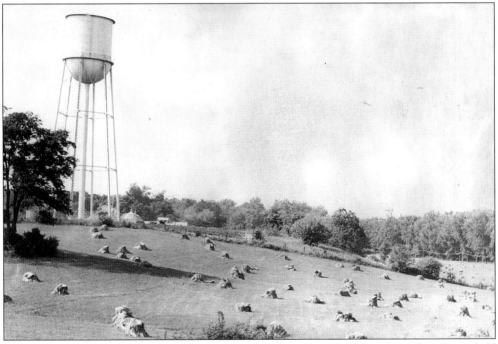

SPRINGFIELD FARM. This photograph shows a small part of the large farm that Springfield Hospital Center owned and operated to help make the center an independent facility. To the left is one of the water towers on the property. (Courtesy of Nancy Barnes.)

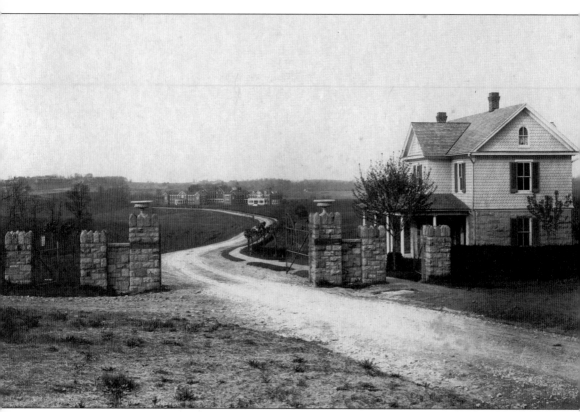

GATE HOUSE. Looking east from Sykesville in this view, this gate house was always a manned entrance to the hospital grounds. Today, after much restoration, it is a genuine first-class museum. (Courtesy of Springfield Hospital Center.)

Six

BUSINESS AND INDUSTRY

Ever since Sykesville was known as "One Horse Stop" by the railroad, a variety of businesses and industries have graced its path. The biggest industry for years was, without a doubt, the railroad, which brought people and jobs to the small town. Without the railroad, Sykesville may have been just another small dot on the map.

The first major business the hamlet participated in was mining. In 1847, James Tyson developed the Elba Furnace, a water and charcoal furnace, on the north bank of the Patapsco River to smelt iron ore. It was wiped out in the 1868 flood. Copper also became a big commodity coming right from Springfield, located on the Patterson estate.

In the 1930s, Farm and Home Service/Southern States was founded. Still in existence, the seed and feed company sits on the southern end of Main Street and has been a partnership of Calvin Day and Martha Crist since 1952. The business originated with Frank Dorsey at Dorsey Crossroads, now Liberty Road and Route 97. Northrop Grumman, the aviation giant, came to town in 1996 after buying out Westinghouse on Route 32 on the east of town. Fairhaven Retirement Center provides a first-class retirement community for seniors as does Copper Ridge, a state-of-the-art Alzheimer's facility. Continuum Care at Sykesville, formerly Sykesville Eldercare, is a top-notch nursing home in the middle of town. A.G. Parrott Paving Company is situated near the town police station.

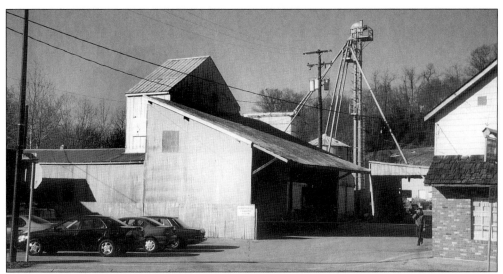

FARM AND HOME SERVICE. This Southern States mill on the south edge of town has been in service for over 68 years. Today, the mixed feeds provided are mainly used by "suburbanite farmers" instead of the operators of large farms in the past. (Photo by the Author.)

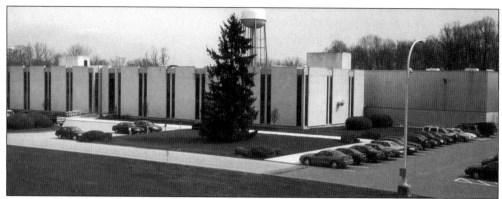

Northrop Grumman. This facility, which makes electronic sensors, bought out Westinghouse Corporation in 1996. Although not actually in town, it still plays an important role in the community. Security and secrecy are a large part of this business as much of what they do provides for national security. (Photo by the Author.)

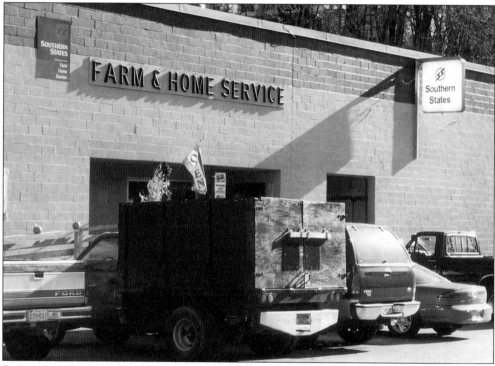

Farm and Home. The service center and warehouse for the Southern States company sits across the street from its mill. Having been in business since the 1930s, the store now sells items ranging from feed, seed, farm and home supplies, roofing, siding, tools, tractors, and fencing. (Photo by the Author.)

FAIRHAVEN. This first-rate senior retirement community center provides numerous activities for its residents. In addition to providing apartments and cottages for residents, it also supports them with assisted living, a health center, and continuing care. (Photo by the Author.)

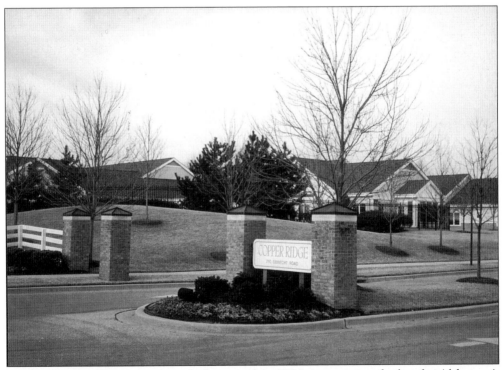

COPPER RIDGE. This company, which opened in 1994, is a nursing facility for Alzheimer's patients. Copper Ridge has the capability to provide for approximately 120 patients and is considered one of the best facilities in the nation for Alzheimer's patients. (Photo by the Author.)

73

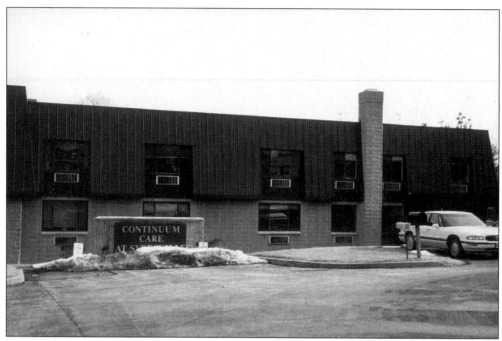

CONTINUUM CARE AT SYKESVILLE. This excellent nursing home facility centrally located in town was purchased in 1995 from Sykesville Eldercare. It maintains 140 beds and employs 110 people from the town and surrounding area. (Photo by the Author.)

SYKESVILLE APARTMENTS. These fine apartment units have been around since 1969 and are located next to Sykesville Middle School on Village Road. The business maintains 253 units. (Photo by the Author.)

FERRELL GAS CO. This propane gas company came to town in 1993 when it purchased Agway Gas. Agway had bought Miller Gas years before. Ferrell's large, commanding tank can be seen along Spout Hill Road near the end of Main Street. (Photo by the Author.)

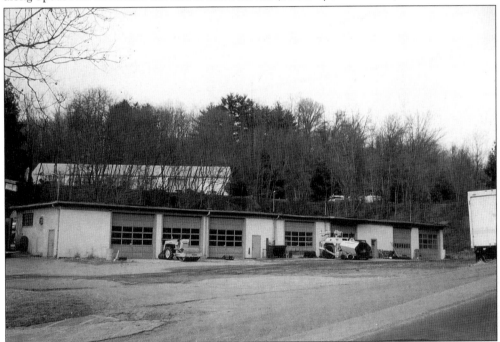

A.G. PARROTT PAVING. Parrot has been a staple in town for years. Much of the paving work around Sykesville is completed by this company, which has an impeccable record. (Photo by the Author.)

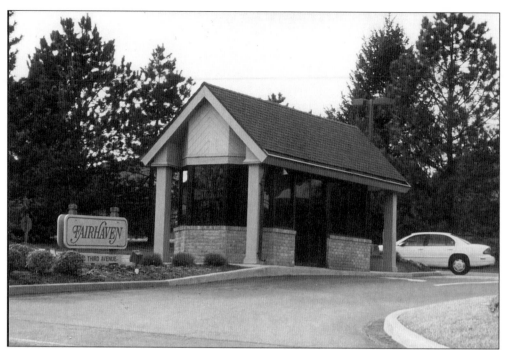

FAIRHAVEN GATE HOUSE. This guardhouse sits at the entrance to Fairhaven and helps to provide some measure of security and assurance to the residents of the facility. (Photo by the Author.)

CHAPEL. Part of the residents' activities are spiritual at Fairhaven Gatehouse, and visible on the left is the chapel. Fairhaven strives to provide a quality of life that is second to none. (Photo by the Author.)

Seven

THE PEOPLE

What is a town? Is it the buildings, the history, or the region? No doubt they are important and a very vital part of the makeup, but the heart and soul of any town is its people. They are the lifeblood that make it breathe and work. Sykesville is no different.

Many people, some famous and some not so famous, have created the Town of Sykesville, a community rich in history. When tragedy struck, they were there to heal. When times of abundance came, they were there to reap. When caring was needed, they were there with open arms. The residents of Sykesville were the hard-workers that made the town what it is today.

Several of the people that are noted in this chapter may not be well known but they are Sykesville. They are what have made this little hamlet such a success story. Names such as Patterson, Sykes, Warfield, Dorsey, Brandenburg, Mellor, Wimmer, Fowble, McDonald, and others are the heartbeat of Sykesville. Without families and individuals such as these and others not mentioned here, Sykesville would just be another spot on the map.

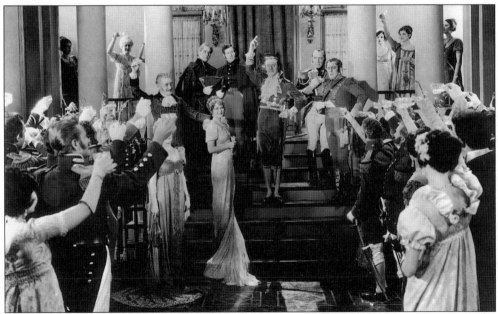

GLORIOUS BETSY PATTERSON. The marriage and divorce of local resident Betsy Patterson in 1803 became world renown due to its implications with the infamous Napoleon Bonaparte. Betsy married Jerome, Napoleon's brother, but Napoleon immediately annulled the marriage even after the Pope denied the divorce. (Courtesy of the Maryland Historical Society.)

JEROME BONAPARTE. This undated photo of Jerome Bonaparte, one of Napoleon's brothers, shows the man that Betsy Patterson fell in love with. Their doomed love affair and marriage, however, was not unfruitful. Betsy bore a son, Jerome Jr. (Courtesy of the Maryland Historical Society.)

SUSANNA WARFIELD. This remarkable lady helped establish St. Barnabas Episcopal Church. In 1882, Thomas Scharf, in his *History of Western Maryland*, characterized Susanna Warfield as a "well-preserved lady of the old-school, dignified and courtly, paying a great attention to current events, and especially interested in the church." (Courtesy of the *Sykesville Herald*, Thursday, May 19, 1966, V. 53, #45.)

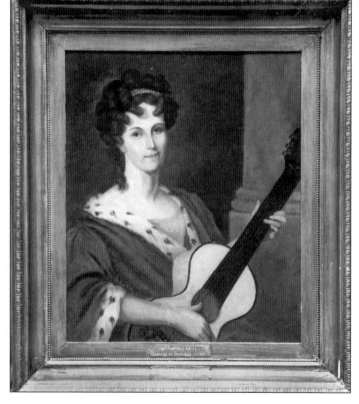

GEN. J.E.B. STUART. Gen. James Ewell Brown Stuart (1833–1864) of the Confederate States of America was one of Gen. Robert E. Lee's most trusted cavalry officers. It was on his way to Gettysburg that Stuart sent a raiding party to the town of Sykesville, creating havoc for the Union contingent and the townspeople. It is believed his raid helped to cause his delay arriving at Gettysburg, possibly changing the course of the battle. (Courtesy of Madison Bay Company.)

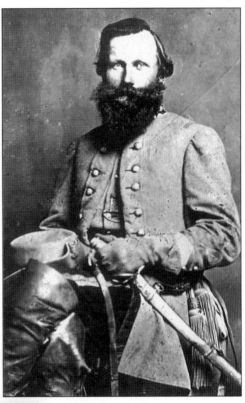

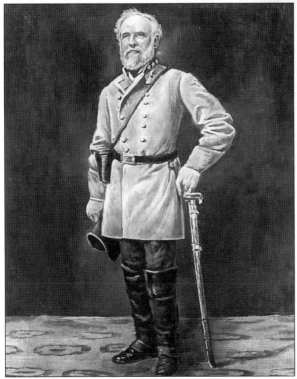

GEN. ROBERT E. LEE. Lee made two visits to Sykesville. The first was on his way to Harpers Ferry to arrest abolitionist John Brown. The second was when he sent troops—via J.E.B. Stuart—to destroy Sykesville's railroad and telegraph lines en route to Gettysburg. (Courtesy of Americana Souvenirs and Gifts, 302 York Street, Gettysburg, PA 17325.)

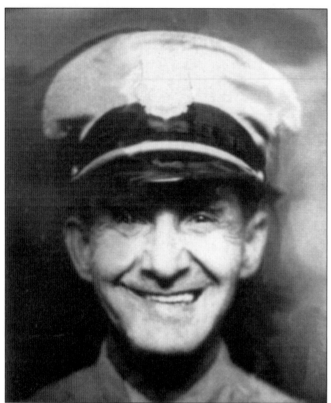

WALTER BRANDT BLIZZARD. From 1932 until his death in 1941, Walter Brandt Blizzard was called the "Town Officer." Most remember his skill at mediating problems in the community without resorting to legal action. Many times instead of jailing drunks, he would drive them home. He enjoyed music and sang in a tenor voice. He loved telling stories about his life on a farm. His life was changed forever when he was left to raise his four daughters alone after a car accident killed his wife, Gladys. (Courtesy of Gwendolyn Blizzard Seemer.)

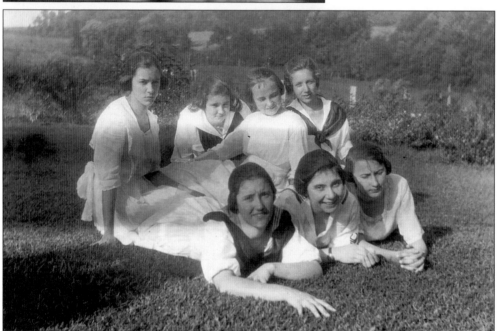

YOUNG LADIES. These young women lay around on the cool grass on a hot, summer day in Sykesville around 1910. The only identifiable one is Helen Harris on the far right. (Courtesy of Helen Gaither.)

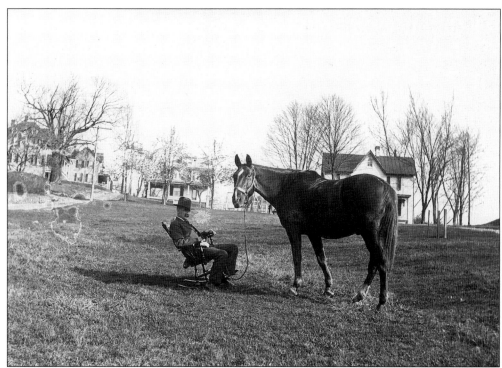

JOHN HARRIS. John Harris is pictured above resting in a chair with his horse nearby. The house behind him to the left was the home of J. Marion Harris. The road on the left is Mellor Avenue. (Courtesy of Helen Gaither.)

FRIENDS. In this *c.* 1924 photograph are, from left to right, Adele Harris, Margaret Harris, and Lorraine Leyfield posing with Mrs. Dora Weer. Mrs. Weer was an accomplished seamstress and her husband was a longtime postmaster for the town. (Courtesy of Helen Gaither.)

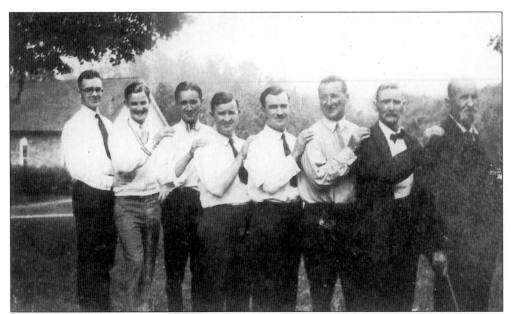

HARRIS MEN. The men of the Harris family are, from left to right, Judge Ley Field, James G. Harris, Paul Harris, J. Marion Harris, Stanley Harris, Irving Harris, John Harris, and Dr. Joseph Steele. This photo was taken in June 1924 at the funeral of Alberta Harris. St. Joseph's Church is in the background. (Courtesy of Helen Gaither.)

WILLIAM MASON JONES. William Jones was an accomplished carpenter and builder of furniture and had a shop on Main Street, which unfortunately burned down in the 1930s. Here, in 1946, Jones stands in his garden. Many people in town who had him work in their homes could attest to his expertise and genuine craftsmanship. Jones's wife, Laura, sitting at her window, would call out to girls as they walked by their home and chant, "Whistlin' woman, crowin' hen, ain't no good for God nor man." (Courtesy of Dolly Hughes.)

JOHN HARRIS. John Harris, husband of Alberta Steele, died in 1926. He was a harness maker and founded Harris Grocery Store in 1901. (Courtesy of Helen Gaither.)

ALBERTA STEEL HARRIS. Alberta Harris married John Harris in 1884 in Eldersburg, Maryland. She was the daughter of Dr. Joseph Wesley Steele and died in 1924. (Courtesy of Helen Gaither.)

MARGARET HARRIS. Margaret Harris, pictured here *c.* 1950, purchased homes in nearby Flohrville, fixed them up, and rented them out cheaply to workers at the Springfield copper mines. (Courtesy of Helen Gaither.)

MARGARET HARRIS. Margaret Harris poses for a picture on her honeymoon. Note the period dress. (Courtesy of Helen Gaither.)

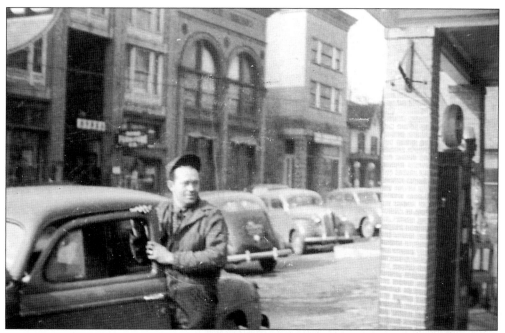

GAS STATION. Dorsey Tucker, a longtime resident, owned a gas station on the corner of what is now Sandosky Road and Main Street. This picture, taken in the 1940s, shows the station pumps on the right. The gas station has since been removed and a carryout has replaced it. Also note how the cars are parked diagonally on Main Street. (Courtesy of Nancy Barnes.)

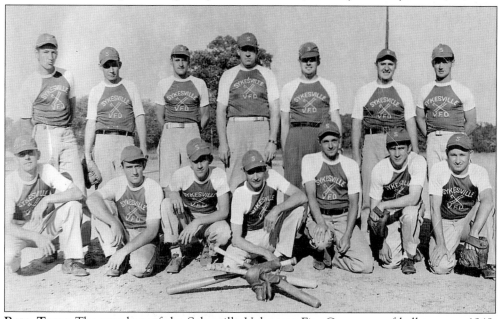

BALL TEAM. The members of the Sykesville Volunteer Fire Company softball team, *c.* 1948, pose for their picture. From left to right are (front row) Paul Smith, Harry Guy, George Etzler, Howard (Stinky) Williams, David Dean, Mickey Ridgley, and Herb Gasnell; (back row) Howard Etzler, Gene Berry, Ed Grimes, Dorsey Tucker, Gene Rogers, Jack Mulliniz, and Monroe Stem. (Courtesy of Nancy Barnes.)

HORACE JEFFERSON. "Captain" Jefferson, as many knew him, was a former tug boat captain for a local tug line in Baltimore. English by birth, the Captain was also a former mayor of Sykesville and owned a beautiful mansion on Raincliffe Road. (Courtesy of the Sykesville Gate House Museum.)

WILLIAM RAY "MAC" McELROY. Mac served as chief of police from 1939 to 1970 and as supervisor of the Public Works Department for 14 years. His total service time to the town was 45 years. In 1992, Sykesville dedicated the new Oklahoma Avenue parking lot to him in honor of his outstanding service to the town. (Courtesy of the Town of Sykesville.)

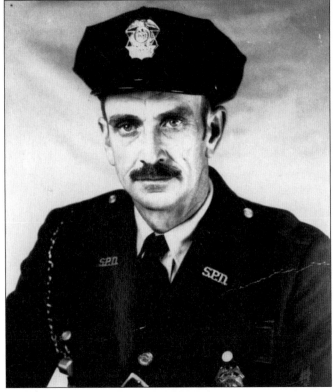

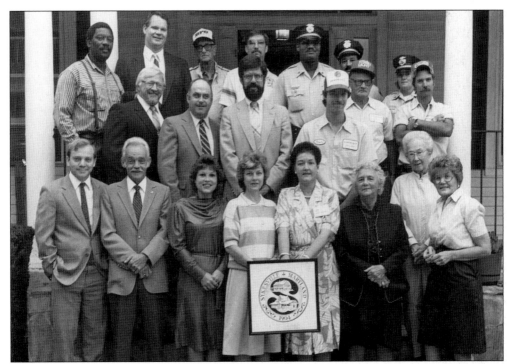

TOWN STAFF. In the 1980s, the town staff assembled for a group photo in front of the Town House with the new seal. From left to right, (front row) James Schumacher, Tim Ferguson, Anna Haney, Dinah Riley, Maxine Wooleyhan, Doris Dixon, Thelma Wimmer (town historian), and Erika Brandenburg; (middle row) Gerald Raines, Charles Mullins, Mayor Lloyd Helt, and Randy Hughes; (back row) Eugene Johnson, Tom Yeasted, William McElroy, Dennis Hoover, Al Griffin, Mike Augerinos, George Rosier, Pamela Skidmore, and James Hollingsworth. (Courtesy of the Town of Sykesville.)

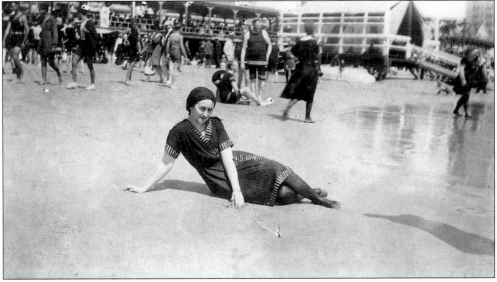

BATHING. Posing in her daring bathing suit in the 1920s, Adele Harris has her picture taken in Atlantic City, New Jersey. (Courtesy of Helen Gaither.)

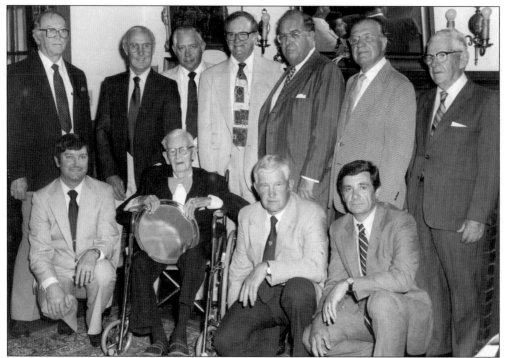

BOARD OF DIRECTORS. In the 1980s, the board of directors of Sykesville State Bank presented a silver tray to J. Marion Harris for his years of service. From left to right are (front row) Harry Weer Haight, J. Marion Harris, Harry Sandosky Sr., and C. Todd Brown; (back row) Howard Hall, unidentified, Leon Etzler, Ken Barnes Jr., C. Rogers Hall, Celius Brown, and Sidney Renehan. (Courtesy of Jim Wilder.)

HARRIS FUNERAL. The Harris family is seen here at the funeral of Alberta Harris in June 1924. From left to right are (front row) Adele Harris with son James, Paul Harris, Margaret and Irving with daughter Lorraine, Marion with daughter Elizabeth, and Anna Steele; (back row) James Harris, Dr. J.W. Steele, John Harris, and Stanley Harris. (Courtesy of Helen Gaither.)

FOURTH OF JULY. These young unidentified girls celebrate the Fourth of July, 1917, oblivious to the fact that the world was going to war. They are playing on the lawn at the Harris home on Mellor Avenue and St. Joseph's Church is in the background. (Courtesy of Helen Gaither.)

THE HARRIS WOMEN. John and Alberta Harris's four daughters, Margaret, Helen, Adele, and Laura, pose for a *c.* 1930 picture on the family lawn. The McDonald home in the background is now the Town House. (Courtesy of Helen Gaither.)

WAR. When duty called, Adele Harris answered. During the Great War, she served in the Red Cross. (Courtesy of Helen Gaither.)

DRIVING 'ROUND TOWN. Adele Harris loved to drive and whenever she got the chance, she would gather up the children in the neighborhood, as shown here, and drive them around the town. (Courtesy of Helen Gaither.)

DELIVERY TRUCK. Margaret Harris poses in front of Harris Grocery Store on Main Street. Note the store's phone number on the delivery truck, "Phone Sykes 192." The hedges along Main Street on the left are still found there today. (Courtesy of Helen Gaither.)

MILLARD COOPER. "Coop," as he was called, was appointed chief of police in September 1964 and he retired in 1975. He was also the town maintenance and snow removal expert. Since his death in 1980, it is said that Coop's ghost haunts the Town House. Some can still smell his cigars in its many rooms. (Courtesy of the Town of Sykesville.)

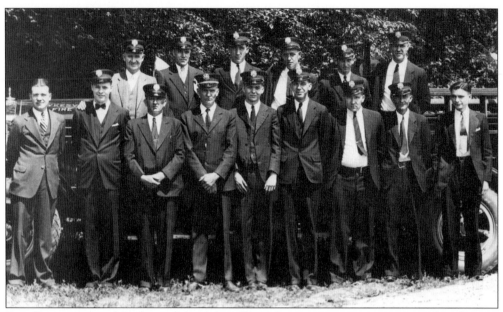

FIRE DEPARTMENT. Members of the Sykesville Volunteer Fire Department stand in front of their brand new LaFrance pumper in 1933. Pictured are, from left to right, (front row) Celius Brown, Horpel Barnes, Clarence Young, Amos Ruch, Charles Wineburg, Robert Frampton, Vernon Bennett, Harry Hesse, and Fred Church; (back row) J. Marion Harris, Henry Forsythe, Terry Dearing, Harvey Cutsail, Rowland Ely, and Marion Brown. (Courtesy of the Sykesville Gate House Museum.)

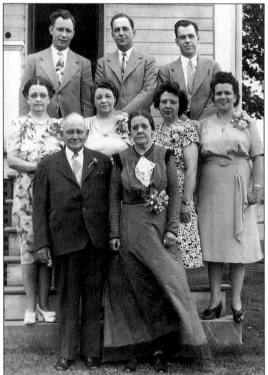

ANNIVERSARY. Eugene and Marian Berry celebrate their 50th anniversary in May 1947 in this photograph. From left to right are (front row) Eugene and Marian Berry; (middle row) Lillian Berry Brown, Louise Berry Brandenburg, Marian Berry Dorsey, and Beatrice Berry Morris; (back row) Eugene Berry, Maurice Berry, and Lloyd Berry. (Courtesy of Dolly Hughes.)

Eight

PUBLIC AND HISTORIC BUILDINGS

The majority of the buildings in Sykesville have been around for many years, but some are gone forever, never to be seen again. Thanks to the community's perseverance, many historic and public buildings have escaped the hangman's noose.

Public buildings, some of which are historic, house government offices and facilities. Over the years a few have undergone drastic changes to remodel the exterior and interior. For instance, the town's new police station used to be a maintenance garage. Before that the police force was housed in a small room in the Town House. On the other hand, the Town House, once the old McDonald home, has been miraculously restored to its original colors and the interior and exterior have been immaculately renovated to represent the period when the home was in its original glory.

Another excellent example of restoration is the Sykesville Gate House Museum of History. Dilapidated and falling apart, this structure has been restored to its original beauty and charm and now houses one of the premier museums in Carroll County and the surrounding area.

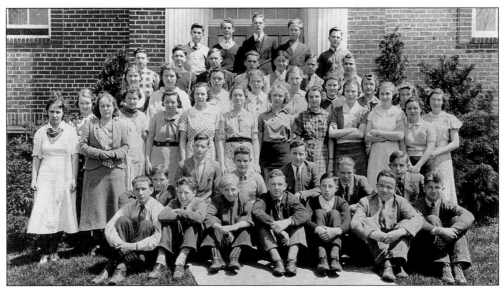

CLASS OF 1938. The Sykesville High School Class of 1938 is pictured here, but the students and teachers are unidentified. (Courtesy of Helen Gaither.)

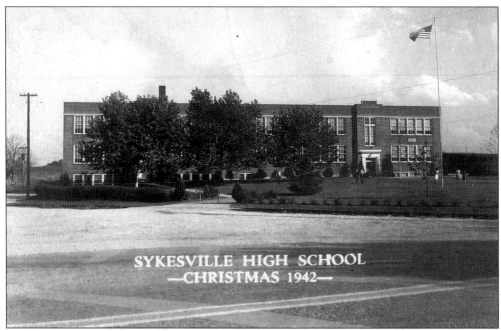

SYKESVILLE HIGH SCHOOL. This 1942 Christmas postcard shows the Sykesville High School in all its glory. Just a little over a decade later, in 1957, fire destroyed the entire school building. (Courtesy of Dolly Hughes.)

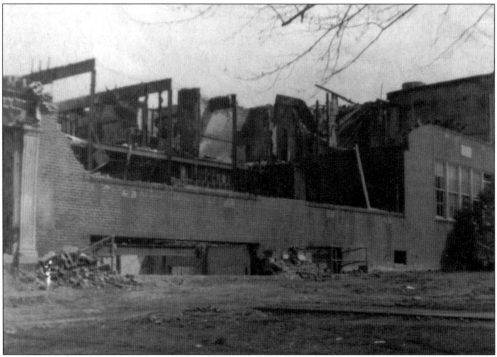

FIRE. The 1957 fire that ravaged Sykesville High School is evident in this picture. Not much was left standing when it was all over. On this site today sits Sykesville Middle School. (Courtesy of Sykesville Gate House Museum.)

SCALE STATION. The old scale station sits on the Howard County side of Sykesville as visitors enter the town from the south. This was used to weigh farmers' produce as they came to market their products. (Photo by the Author.)

SYKES OFFICE. This structure, long purported to be the office of James Sykes, for whom the town was named, rests on the Howard County side of the Sykesville Bridge on the south end of town. Though the structure is badly run down, preservationists are hoping to work with Howard County officials to restore it to its former glory. (Photo by the Author.)

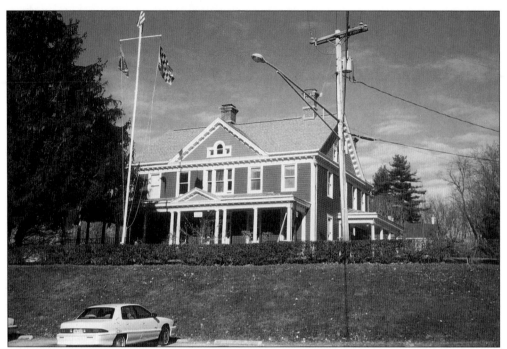

TOWN HOUSE. The town offices are housed in the Victorian-style McDonald house on the east side of Main Street. Several recent renovations have restored the former beauty of this unique home. (Photo by the Author.)

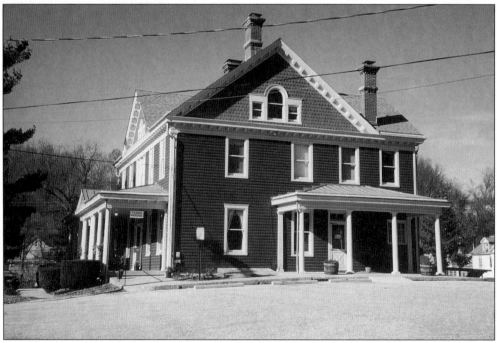

TOWN HOUSE. Newly repainted to its original colors, the Town House sits above Main Street, restoring faith in the historical accuracy of Sykesville. Housed here are the town manager, mayor, clerk-treasurer, and administrative staff. (Photo by the Author.)

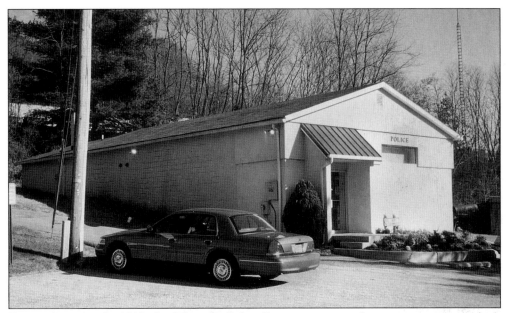

POLICE STATION. In 1992, the Sykesville Police Department moved into its new station which was renovated from an old maintenance garage. Before moving into this station, the department operated out of a small office in the Town House. Prisoners used to be handcuffed to radiator pipes in the one-room office. Now, thanks to town officials with a vision, they are housed in a state-of-the-art holding cell. (Photo by the Author.)

GATE HOUSE MUSEUM OF HISTORY. Built in 1904, the Gate House used to accommodate Springfield Hospital Center administrators, doctors, staff, and students. An administrator, William Shorb Shipley, lived at the house for 40 years from 1913 to 1954. The museum began in the Town House in rooms designated for history by Thelma Wimmer, the official town historian. Today there is a beautiful museum of history with its first curator, Jim Purman. (Photo by the Author.)

GATE HOUSE FUN. A young Nancy Tucker Barnes had a lot of fun swinging on this wrought-iron gate at the Gate House. Note the stone post and iron gate. Today the stone post is still there but the gates have long gone. The Gate House is in the background. (Courtesy of Nancy Barnes.)

SCHOOL HOUSE. The Black School House sits at the "bottom" of Sykesville, as many residents have known the area. This one-room schoolhouse was the place where black children were taught beginning in 1904. After 1938, the building was turned into a dwelling. Since then, years of decay have almost destroyed the building. Again, preservationists have done a remarkable job returning the schoolhouse to its earlier beauty. Ongoing projects are still in progress. On July 30, 1999, the school was placed on the "Save Maryland's Treasures" list. (Photo by the Author.)

BLOCK GRANT. In the 1980s Sykesville was fortunate to receive a Community Development Block Grant from the State of Maryland. Pictured, from left to right, are Mayor Lloyd Helt, Gov. William Donald Schaefer, Town Manager James Schumacher, and Councilman Tim Ferguson. (Courtesy of the Town of Sykesville.)

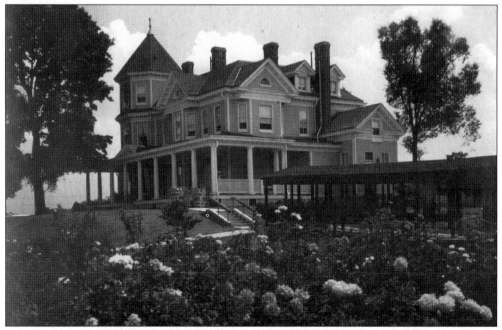

BEASMAN MANSION. This gorgeous mansion belonged to the Beasman family and stood proud on the north end of town. Tragically, in the 1980s, it was demolished before anyone could do anything to save it. (Courtesy of the Sykesville Gate House Museum.)

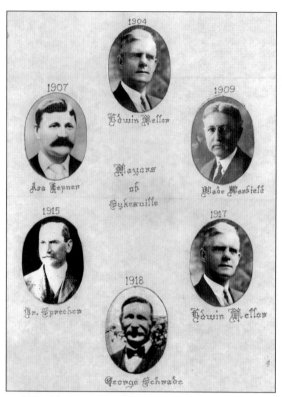

MAYORS OF SYKESVILLE. The first six mayors of Sykesville are shown in this panoramic shot. They are, clockwise from the top, Edwin Mellor (first mayor of Sykesville), Wade Warfield, Edwin Mellor, George Schwade, Daniel Sprecher, and Asa Hepner. (Courtesy of the Town of Sykesville.)

WILLIAM BRANDENBURG. Mayor William Brandenburg sits in front of his desk in 1974 showing the scissors that cut the ribbon to Sykesville's first major parking lot. Brandenburg also served in the U.S. Navy and was an active Mason. (Courtesy of Dolly Hughes.)

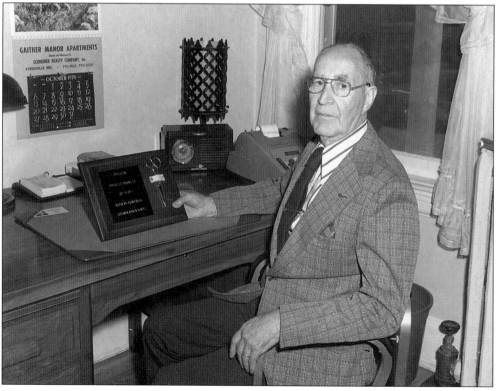

MAINTENANCE SHED. Sykesville's maintenance shed serves as a storage facility for salt, stone, etc., and quarters for the maintenance department. Snow plows, recycling equipment, and other items are also stored here. (Photo by the Author.)

TRASH TRUCKS. Sykesville is one of the very few towns in Carroll County that provide trash pick-up for its citizens. Trash was picked up twice a week until the early 1990s. Since then it has been once a week and recycling once a week. The recycling program has been a stellar success. (Photo by the Author.)

SYKESVILLE MIDDLE SCHOOL. Sykesville Middle School sits on the former grounds of Sykesville High School. Many other activities occur in the school in addition to educating the students. Community meetings, basketball games, and other events are held here. (Photo by the Author.)

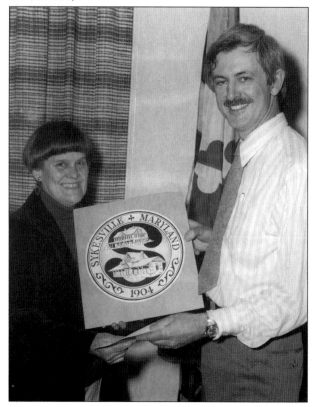

TOWN LOGO. In the late 1970s, Sykesville received its first official logo prepared by local Eldersburg artist, Betty Luebberman. Here, she presents the logo to Mayor Robert Killett. (Courtesy of the Town of Sykesville.)

Nine

THE JONES SISTERS

Mention the Jones sisters in Carroll County and almost everyone has heard of them. The three sisters, Fannie, Ida, and Elsie, were renowned from the 1920s through the 1940s for their hand-painted photographs of historic places in Maryland and their still-life images of flowers and scenery. Even the famous Audrey Bodine stated, "I could reach up and pull the flowers right out of the picture."

The sisters' father, Nicholas Jones, farmed and owned Annandale Farm, and their mother, Julia Agnes Webb, was a housewife. An unmarried uncle, James Armstrong Jones, also lived on the farm with the family. When they came to Sykesville, the family resided at Sunnybrook at the corner of Springfield and Central Avenues.

Elsie, the youngest, purchased her first camera in the 1930s and began taking photos of historic places. Ida hand-painted each print. Francis (Fannie), the oldest, kept house and cooked. The sisters also created beautiful tablecloths and pieces of fine cutwork. In 1952, the sisters decided to open the Sunnie Holmes Studio in Sykesville, which flourished until 1964.

Today, many people in and around Sykesville own Jones sisters paintings. According to Katuria Springer, a longtime resident and collector, "Almost everyone who got married in the 1940s in the Sykesville area received either Candlewick Crystal or Jones sisters photographs purchased at DeVries Hering Hardware Store." Cousins of the talented sisters maintain a large portion of the Jones Sisters work and artifacts today. The Jones sisters have left an indelible memory of their work to a community that has shown great respect for their efforts. It is to their memory that this chapter is dedicated.

HUSKERS REWARD. One of the most popular pictures by the Jones sisters, "Huskers Reward" details the reward of farming in a rural community. (Courtesy of the Jones Sisters Collection.)

NICHOLAS STUBY JONES. This picture shows Nicholas Jones in 1863 at the height of the Civil War. Jones was a busy man—he owned and farmed Annandale and owned two homes in Sykesville. (Courtesy of the Jones Sisters Collection.)

JULIA A. WEBB. This 1880 photograph shows Julia Webb, the wife of Nicholas Jones and mother of the Jones sisters. (Courtesy of the Jones Sisters Collection.)

JULIA WEBB. This photograph was taken in 1909, 29 years after the one on the previous page. (Courtesy of the Jones Sisters Collection.)

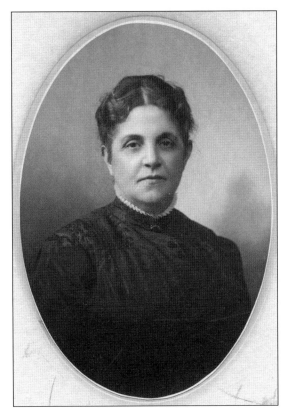

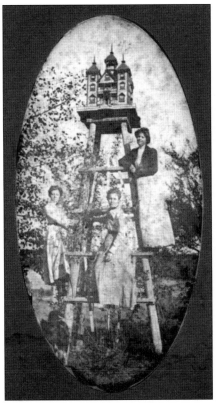

THE MARTINS HOUSE. This undated photo shows the Jones sisters standing on a ladder to admire a Martins birdhouse on their property. (Courtesy of the Jones Sisters Collection.)

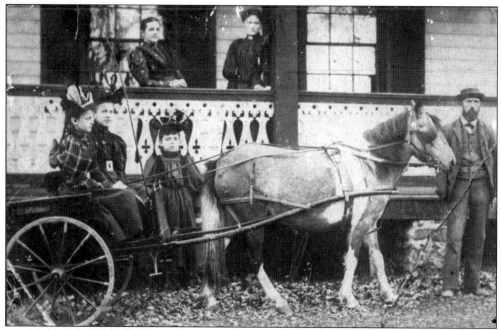

HITCHING A RIDE. The Jones sisters along with their mother, governess, and father posed for this picture in front of their Annandale home. (Courtesy of the Jones Sisters Collection.)

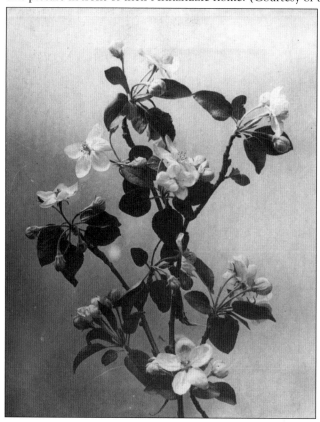

APPLE BLOSSOMS. The girls loved to capture flowers and scenery. Here is one of their hand-painted photo's titled, "Apple Blossoms." (Courtesy of the Jones Sisters Collection.)

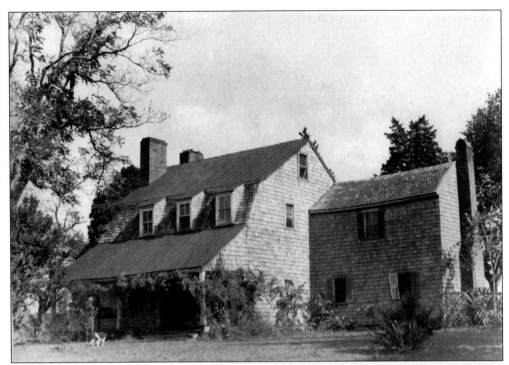

HOUSE. Above is an undated and unknown home photographed and painted by the sisters. (Courtesy of the Jones Sisters Collection.)

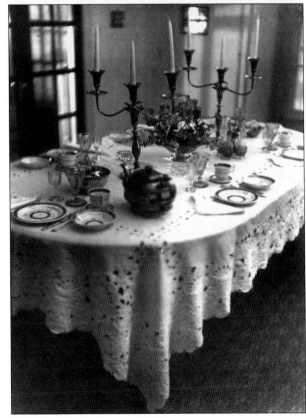

TABLE SETTING. Photography and painting were not the sisters' only talents. Quite evident here is a beautiful example of their cut work and table cloths. (Courtesy of the Jones Sisters Collection.)

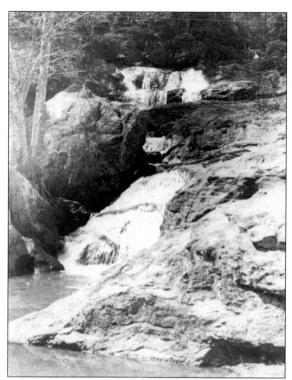

CATOCTIN FALLS. This majestic picture of the falls shows the beauty the sisters were able to capture in even the simplest things. (Courtesy of the Jones Sisters Collection.)

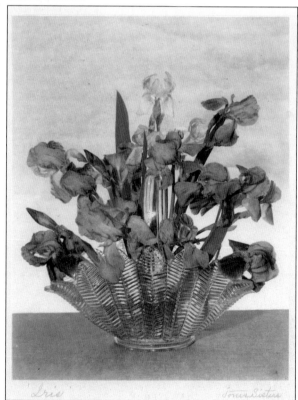

IRIS. A simple still life yet a beautiful picture of nature, the iris in a basket picture shows the sisters' talent at realism. (Courtesy of the Jones Sisters Collection.)

108

HOLLYHOCKS. Another fine example of their artwork is this picture of "Hollyhocks." (Courtesy of the Jones Sisters Collection.)

ROSES. Roses in a vase sit in perfect harmony. This photo shares the sisters' warmth for perfection. (Courtesy of the Jones Sisters Collection.)

FANNIE AS A CHILD. Fannie sits with her doll in this photograph. (Courtesy of the Jones Sisters Collection.)

FANNIE JONES. Fannie grew into a lovely, young woman. The girls were well clothed by their parents as is evident in this view. (Courtesy of the Jones Sisters Collection.)

ELSIE JONES. Elsie was the youngest of the three sisters. It was her adoration for photography that caused her to purchase her first camera in the 1930s for a whopping $125. (Courtesy of the Jones Sisters Collection.)

IDA JONES. A young Ida Jones sits with hat in hand for this early picture. The artist in her was just beginning to bud. (Courtesy of the Jones Sisters Collection.)

IDA JONES. An elegant Ida Jones stands in a Victorian pose. Ida did all of the photography development for the sisters. (Courtesy of the Jones Sisters Collection.)

SPRINGFIELD PRESBYTERIAN CHURCH. This simple photograph captures the heart of Springfield Presbyterian Church as the Jones sisters' pictures often did. (Courtesy of the Jones Sisters Collection.)

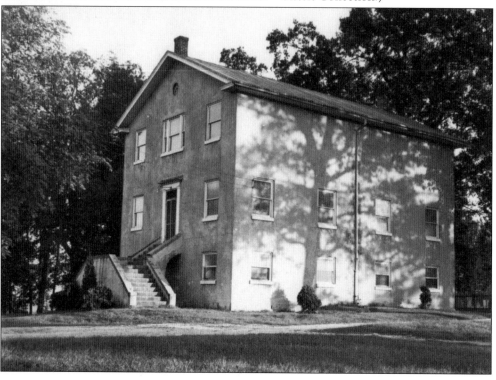

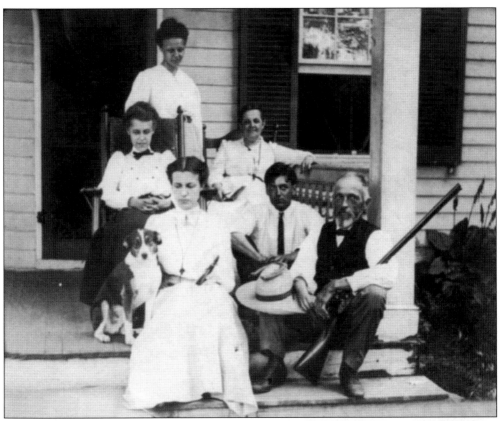

FAMILY ON PORCH. In this undated photo, the Jones sisters sit on their porch with mother, father, and an unidentified male friend. (Courtesy of the Jones Sisters Collection.)

PATIMAS RIVER. This picture depicts a serene natural setting. The winter must not be too cold because the river shows no signs of icing yet. (Courtesy of the Jones Sisters Collection.)

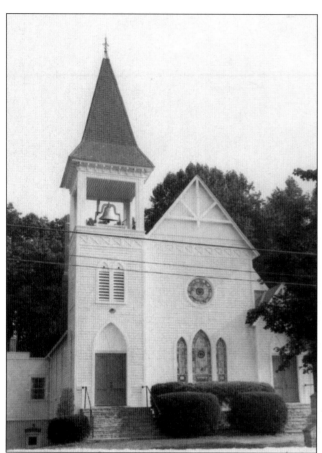

ST. JAMES CHURCH. Though labeled St. Paul's Church, this is actually St. James United Methodist Church in Howard County, three miles south of Sykesville on Route 32. The sisters loved to photograph historic places and churches. (Courtesy of the Jones Sisters Collection.)

ANNANDALE FARM. This farm, surrounded by a beautiful landscape, was owned by Nicholas Jones. (Courtesy of the Jones Sisters Collection.)

PATAPSCO RIVER. Many photographs were taken locally and this one is of the Patapsco River in Sykesville. The flowing river is serene in this photo but can easily be turned into a raging monster during a storm. (Courtesy of the Jones Sisters Collection.)

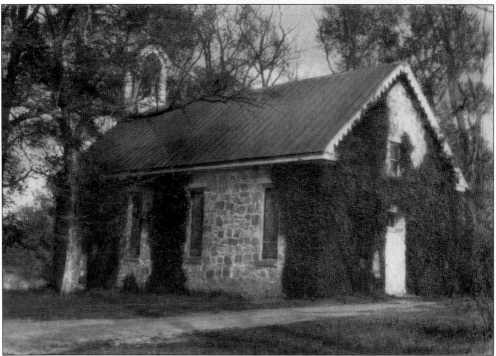

ST. BARNABAS CHURCH. This unique photo of St. Barnabas Episcopal Church shows the building almost covered in ivy. Today the ivy is gone but the church still stands. (Courtesy of the Jones Sisters Collection.)

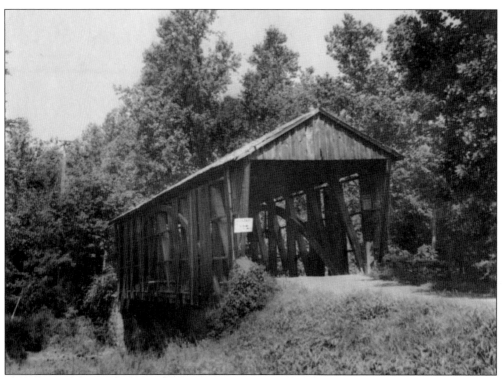

COVERED BRIDGE. This covered bridge is like so many around the country yet the sisters were also able to capture the feeling of a day gone by in their picture. (Courtesy of the Jones Sisters Collection.)

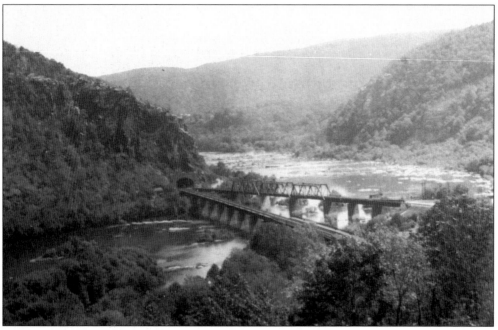

HARPERS FERRY. An important town in American history, Harpers Ferry rests between the mountains in this Jones sisters' picture. (Courtesy of the Jones Sisters Collection.)

OLD IRONSIDES. The USS *Constitution* rests in Boston Harbor surrounded by a small flotilla of work boats waiting for orders. Historical sites are a favorite for photographers, and the Jones sisters are no exception. (Courtesy of the Jones Sisters Collection.)

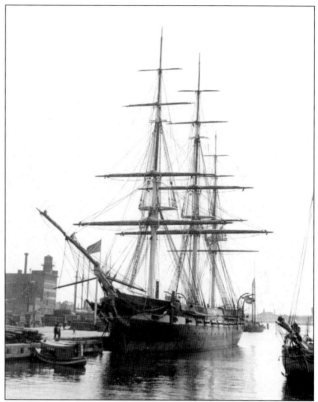

FORT McHENRY. Another favorite piece of history was Fort McHenry in Baltimore City, Maryland. The sisters capture the tension of the moment as if the cannons are ready to fire into a waiting British naval force. (Courtesy of the Jones Sisters Collection.)

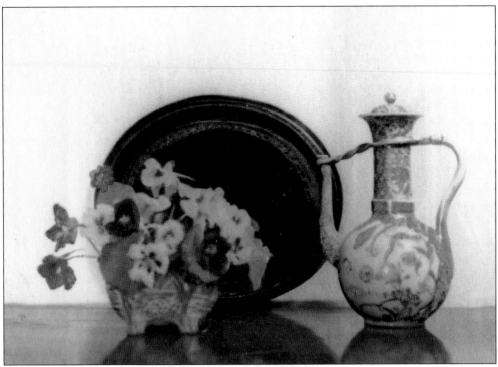

NASTURTIUMS. A vase of nasturtiums, a platter, and a pitcher set the mood for this still life. (Courtesy of the Jones Sisters Collection.)

DRUID HILL PARK. A favorite place to go for a visit, Druid Hill Park was one of Baltimore's premier attractions. Here, the sisters captured the beauty of its lovely flower gardens. (Courtesy of the Jones Sisters Collections.)

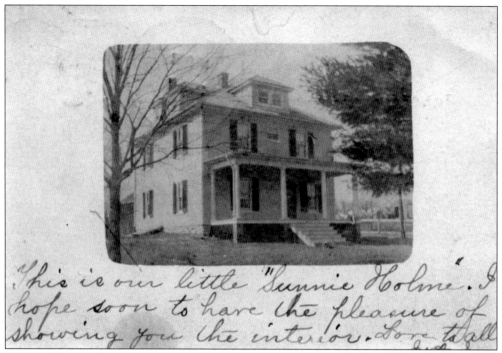

This is our little "Sunnie Holme". I hope soon to have the pleasure of showing you the interior. Love to all

SUNNIE HOLME. This is the studio home that the Jones sisters worked out of from 1952 to 1964. It sits on Springfield Avenue in Sykesville. (Courtesy of the Jones Sisters Collection.)

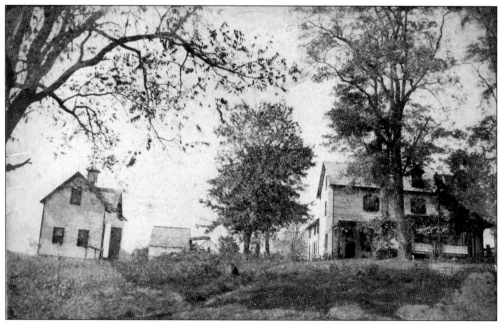

ANNANDALE FARM. This picture depicts the Annandale Farm and outbuildings. The house on the far left was the school that the Jones sisters were taught in by their governess. (Courtesy of the Jones Sisters Collection.)

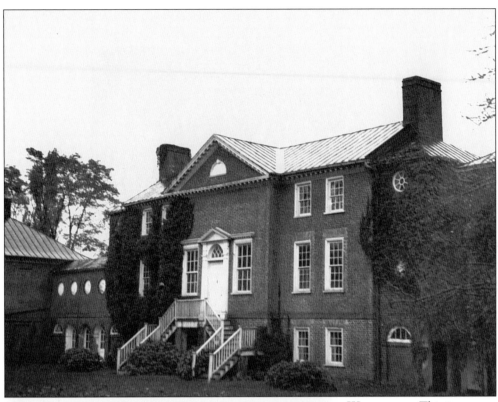

WHITEHALL. This is a picture of historic Whitehall in Anne Arundel County, south of Sykesville. The sisters caught the spirit of the ivy-covered brick Colonial-style building in this photo. (Courtesy of the Jones Sisters Collection.)

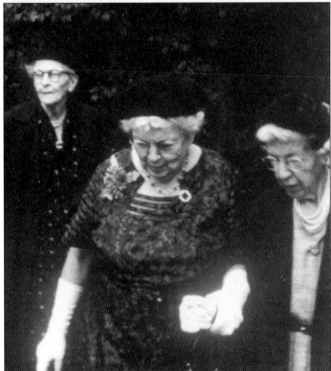

THE JONES SISTERS. In a rare photo of the sisters, they are seen in their later years. From left to right are Fannie, Elsie, and Ida. Elsie had worked in the art department of a famous downtown Baltimore department store named Hochschilds. (Courtesy of the Jones Sisters Collection.)

Ten

WARFIELD COMPLEX

Probably the greatest thing to happen to the Town of Sykesville since its incorporation in 1904 was the annexation of the Warfield Complex, a sprawling 138 acres acquired from the State of Maryland in 1999. Sykesville received the deed for the property in 2001. Warfield was originally a part of the Springfield Hospital Center, formerly the Second Hospital for the Insane in the Hygiene State of Maryland, founded in 1896. Since then the two have been inseparable. The complex was named for the Warfield family whose members were very active in the community. Sykesville's Main Street ran uphill into the complex at the Gate House. Beautiful brickwork, tall white columns, and a turn-of-the century opulence that rivals even Williamsburg herald the fortunate visitor.

All of the buildings have served the hospital center in the past. Unfortunately, due to a declining patient base at the hospital over the years, many of them sat empty, idle, and deteriorating. Yet their stability and beauty have remained intact. It is hoped that Carroll Community College will have a satellite campus. The State of Maryland agreed to take over the Hubner and T Buildings for a statewide police training facility. The complex is planned to house H.E.A.T. (Higher Education and Advanced Technology) centers, businesses, and incubator spaces for small businesses. Green space at the complex helps present an appearance compatible with nature and man.

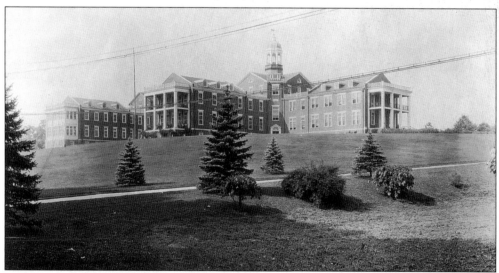

HUBNER BUILDING. The intent of the builders was to make Hubner, constructed in 1915, a model for the State Hospital system in Maryland. For the first time in Springfield State Hospital's existence, male and female patients would be housed under the same roof. (Courtesy of Nancy Barnes.)

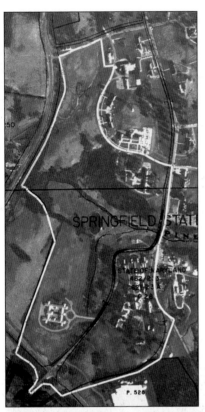

WARFIELD COMPLEX. This map shows the complex in its entirety. Sykesville is to the left. The bulk of the buildings are at the bottom right. Hubner and T Buildings are center. (Courtesy of Town of Sykesville.)

GOVERNOR'S MEETING. Maryland governor Parris Glendenning discusses the acquisition site on a map with Sykesville mayor Jonathan Herman and State Delegate Ellen Willis. (Courtesy of the Town of Sykesville.)

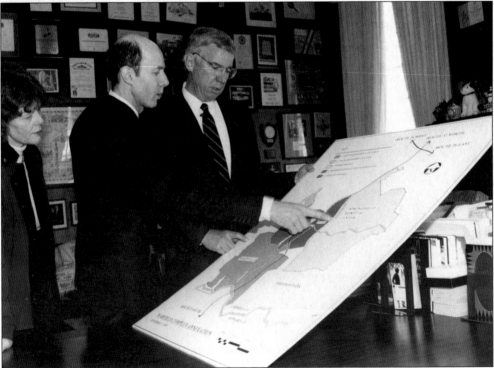

DINING HALL. The dining hall is one of the most elegant buildings in the complex. A brick driveway used by trucks for deliveries encircles the hall. On the south end of the driveway is an underground bunker presumably used as an ice cellar. (Photo by the Author.)

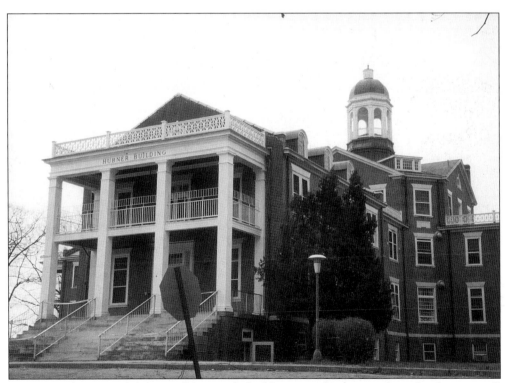

HUBNER. This is another view of the stately building, one that is in a class of architecture all its own.

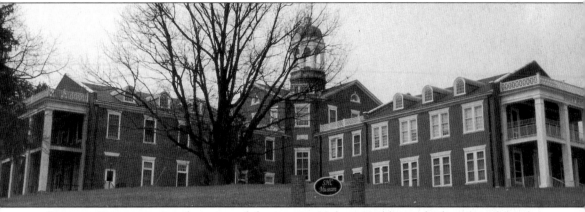

HUBNER BUILDING. Another view of the massive Hubner Building, which was used for the reception, diagnosis, and treatment of acute mental disease patients. In the near future, a statewide police training facility will be housed here and at the T Building. (Courtesy of the Town of Sykesville; photo by the Author.)

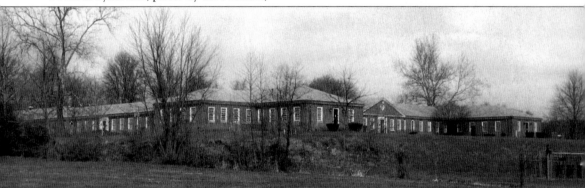

LANE BUILDING. This square building with an open central space was built to house combative patients. It also contained a gymnasium and recreation center. (Photo by the Author.)

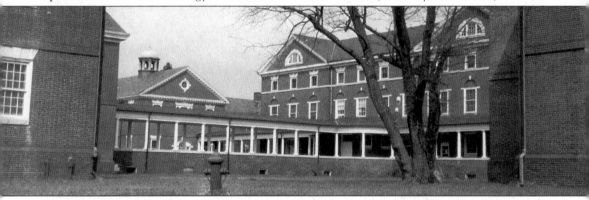

SERVICE GROUP. On the far right and left forefront sit the A and B Buildings. In the center, across the grounds, is the C Building. The long building to the right center is the Service Building. The Colonial Revival buildings were the first ones built for female patients. All four buildings use perpendicular pavilions that are connected by central blocks. The Service Building housed all intake and reception services for the Women's Group until Hubner was built in 1915. (Photo by the Author.)

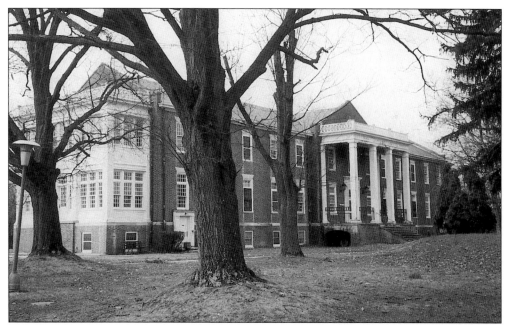

T BUILDING. Like a picture out of the antebellum South, the T Building sits majestically amidst indigenous trees. Designed by Henry Powell Hopkins in 1938 and built in 1939, the building housed only male tuberculosis patients. Church services were held sporadically in this building and others. (Photo by the Author.)

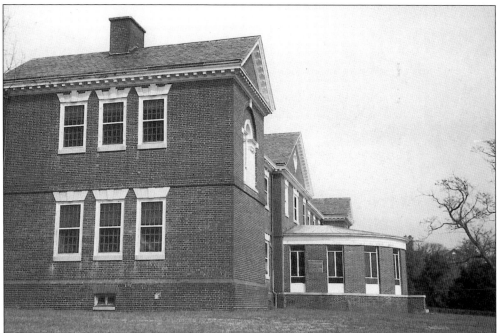

A BUILDING. The A Building sets up the beginning of the Quadrangle (A, B, C, and D) buildings. Opened in 1900 for the first female patients, the two-story Colonial Revival structure is connected physically to the colonnade walkway that joins the four buildings. (Photo by the Author.)

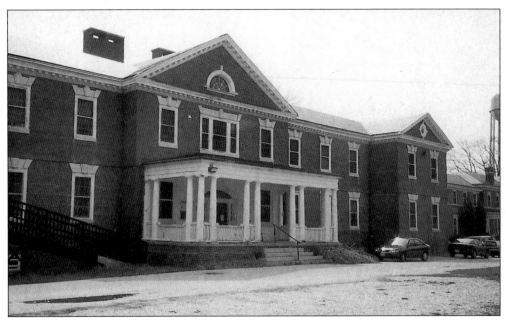

WARFIELD GROUP D COTTAGE. Wooden, Greek Doric columns greet the visitor immediately upon arrival at this building. Its wooden cornices, slate gabled roof, and brick chimney flanking either side are very apropos for the period. (Photo by the Author.)

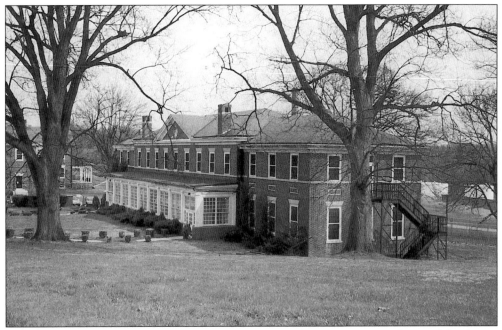

WARFIELD GROUP E COTTAGE. The E Cottage lies south of D Cottage and east of the dining hall. It is a 15-bay by 3-bay, two-story, Flemish Bond brick structure with a slate roof. (Photo by the Author.)

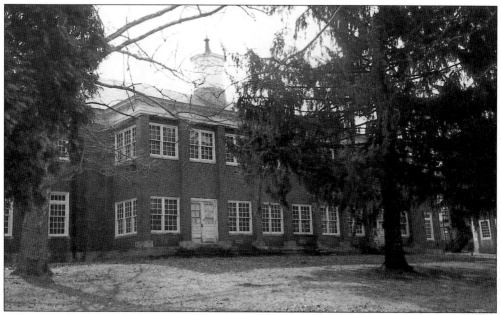

WARFIELD GROUP F COTTAGE. Also known as the Austin Crothers Cottage, this building aligns with the road, unlike the other cottages. It is a two story "L" shaped structure and one of the few buildings with a cupola on the roof. (Photo by the Author.)

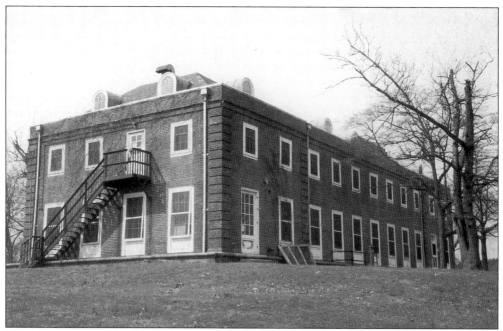

WARFIELD GROUP G COTTAGE. Built in 1927, this U-plan, two-story structure faces south away from the other Warfield buildings. This building has the inscription of its date of construction etched into its stone, "AoDOMINI MCMXXVI." (Photo by the Author.)

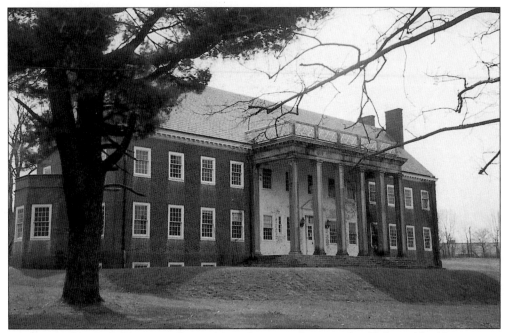

WARFIELD GROUP I COTTAGE. Facing Main Street to the west, this T-shaped building sits on a man-made semi-circular terrace. The west elevation has a poured concrete deck supporting six square, paneled Doric limestone columns. (Photo by the Author.)

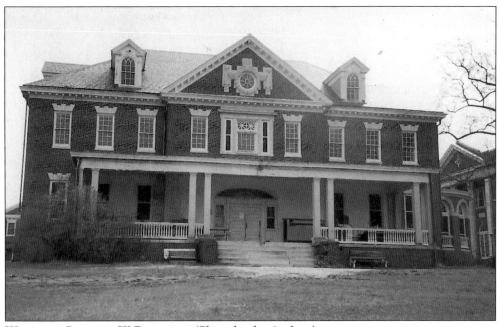

WARFIELD COTTAGE W BUILDING. (Photo by the Author.)